G000067181

ALL HAIL THE GLORIOUS NIGHT

AND OTHER CHRISTMAS POEMS

KEVIN CAREY

ILLUSTRATED BY KEVIN SHEEHAN

Sacristy
Press

Sacristy Press

PO Box 612, Durham, DH1 9HT

www.sacristy.co.uk

Individual volumes first published in 2012,
2013, 2014 and 2015 by Sacristy Press.
This edition first published in 2019 by Sacristy Press.

Copyright © Kevin Carey 2012, 2013, 2014, 2015, 2019
The moral rights of the author have been asserted

Illustrations Copyright © Kevin Sheehan 2015

All rights reserved, no part of this publication may be reproduced
or transmitted in any form or by any means, electronic,
mechanical photocopying, documentary, film or in any other
format without prior written permission of the publisher.

All rights reserved, no part of this publication may be reproduced
or transmitted in any form or by any means, electronic,
mechanical photocopying, documentary, film or in any other
format without prior written permission of the publisher.

Sacristy Limited, registered in England & Wales, number 7565667

British Library Cataloguing-in-Publication Data
A catalogue record for the book is available from the British Library

Paperback ISBN: 978-1-78959-051-7

for
Alan Smith
his wife Sheila
and their children.

PREFACE

I am often asked, as a creative writer, whether I wait for inspiration before committing myself "to paper" or whether I work to a routine. Like most such questions, it implies a false dichotomy. Throughout my life I have had sudden, irresistible urges to write in a certain genre—poetry, novels, hymn lyrics, Christmas verse, and, currently, plays—which have dissipated as quickly as they came. During the realisation of such urges I have always established a writing routine.

The sudden urge which overtook me some ten years ago to write Christmas verse has now left me and so this is a good time to gather the fruits of a decade into one volume. My primary purpose all along has been to provide composers of Christmas carols with a variety of new verse. Over 600 years there have been scores of settings of many of the set Christmas texts but the invention of broadcasting and recorded music has tended to give favour, if not a monopoly, to certain settings, such as Harold Darke's setting of Christina Rossetti's *In The Bleak Midwinter* in spite of a fine setting by Holst, and Mendelssohn's setting of *Hark! The Herald Angels Sing* in spite of a multitude of tuneful predecessors; and it is inconceivable that either *Silent Night* or *Away in a Manger* could be parted from their original tunes. As a chorister in two church choirs I became increasingly aware over almost three decades that there was a large deficiency in the resources available to contemporary composers, most poignantly represented to me in John Tavener's setting of Blake's *The Lamb* whose relevance to Christmas taxes ingenuity.

I was greatly honoured by my musical collaboration with Alan Smith, who died last year and to whom this collection is dedicated. He set many of my pieces, one of which obtained a Royal School of Church Music prize and gained entry into the *Oxford Book of Flexible Carols*. It is hoped that the aggregation of my Christmas

works between just two covers may bring them to the notice of more composers, but I know that many of the verses on the page have given pleasure.

Christmas is not quite as yet in the throes of the same crisis as Easter but it is in serious danger of being swamped by the man in the red coat and his pagan antecedents, and so we must do everything we can in prayer, study, Nativity Plays and the singing of Carols to keep the story of the birth of Christ alive in the middle of Winter. If this collection advances that aim I shall be amply rewarded.

Kevin Carey
Hurstpierpoint, West Sussex
Octave of Easter 2019

MUSICAL SETTINGS

The verse in this collection can be readily set to music and it is the author's earnest hope that some of it will. The author would be very pleased to hear from composers who may be interested in setting any of these lyrics. Please contact the publisher if you would like to do so.

The Infant King has been set in full score by Alan Smith. His setting of its final movement, *In the Beginning*, won the Harold Smart Composition Prize in 2008 and was subsequently published in *The Oxford Book of Flexible Carols* (OUP, 2009). Alan's setting of *Come, Jesus, Come!* was published in 2010 by Augsburg Fortress.

CONTENTS

VOLUME I

A STRANGER IN BETHLEHEM

2012

PREFACE TO VOLUME I

Carols are the part of Christianity that spill over into the whole world. Many people who never go to church feel ownership of old favourites. But, as is so often the case, non-believers can be much more conservative in their view of Christianity than many believers who enjoy new words and settings.

As a chorister, singing old favourites in the parish church and sometimes "posh" carols in another choir, I am privileged to sing in Advent, Christmas, and Epiphany carol services. Over the years I have enjoyed many fine new settings, but the words themselves haven't changed much. So one of the things this book does is to provide both readers and composers with new texts.

Because the story is so briefly told in the Gospels and the number of characters so small, the carol-writer faces some particular challenges: a certain imagination must be applied without straying beyond incredulity; a degree of empathy is called for, but without straying into sentimentality; and then there is the limited stock of rhyming words, exemplified by Mrs Alexander's words for *Once in Royal David's City*, such as: light, bright and night; shed and manger bed; child and mild.

The carols in this volume are set out in approximate chronological order with a few pieces of more general reflection interspersed, with *The Infant King* at the end providing an encapsulation of all the rest. Every time I read the words or hear the musical setting of *In the Beginning* I simply wonder how I ever came to write these tender words during such a tedious meeting at the European Commission!

I frequently have fantasies about preaching, to a packed church at Midnight Mass, that the biographies of great people would be severely inadequate if they stopped at the end of the subject's school

days. This is why it is so hard to keep the death and resurrection of Jesus out of my thoughts when writing Christmas words. But there is a time for everything and I wish you joy when you read these verses. Good Friday will come soon enough.

Kevin Carey
Hurstpierpoint, West Sussex
The Feast of St Luke, 2012

STELLA MARIA

And did that star shine over Calvary
Which lit the Magi where the infant lay,
A distant comfort in her reverie
As Mary left the Cross that fateful day?

And did it guide the angels in their flight
As He lay quiet in the virgin tomb
As it had shone upon the exile night
He left the comfort of the Virgin's womb?

And did it fitly fade before His face,
Our risen Saviour on that Easter morn'
Turning her sorrow with His radiant Grace
To wild Magnificat that he was born?

It shines now on benighted Bethlehem
And on the vastness of our troubled sea;
And, as He is our God but still a man,
Was she the star at the Nativity?

JOSEPH'S REVERIE

I sometimes forgot at the wood shavings' fall,
As He carefully reckoned the line of a wall,
That an angel had called Him the ruler of all

But I never forgot what His mother had said
Of the angel's request and the price on their head
And I dreamed of stones flying and my love lying dead.

And I dreamed of the slaughter of babes at the breast
And I dreamed of the pyramids' uneasy guests
And from dreamings and angels I never had rest.

And I never had rest as my son strode the land
With a smile on his lips and a staff in his hand;
A hand-to-mouth preacher of royal command.

But the king that connived and the crowd that reviled
Were as sane as a plumb line and wolfishly wild;
And the priests would not pray at the death of my child.

And the death of my God's Son was for the world's good
And He rose from the tomb; but I wish that He could
Have used anything other than nails and wood.

I sometimes forget with my nails and my wood
The degree of His suffering as well as I should;
But His mother was special, so she understood.

FIRST NOEL EXCLUSIVE!

A labourer and his pregnant girl arrived
In Bethlehem and looked round for a bed
But when the barman saw she had no ring
He took their cash and pushed them in a shed:
"You know the rules; no get-out clause allowed
For labour pains or holy virgin births,
The occupying powers are very harsh.
Come on, you know it's more than my job's worth."

A rumour of the curious travellers' tale
Spread, like all welcome gossip, through the town
And farmhands bored with minding landlords' sheep
Were glad of an excuse to hang around:
"Besides", they said: "We've felt it in our bones;
There's something up; this isn't what it seems.
All of us sleep like logs on the night shift
But we've been messed about by funny dreams."

But they were decent men who all mucked in,
Collected blankets, gave the barman hell,
As usual, called the midwife far too late
But eagerly fetched water from the well.
"We won't take anything for what we've done;
You may be right, your son may be a King;
But working people lose when times get rough
And Herod's rough by any reckoning."

A Commission of Enquiry came along
Said to be clean but in the Emperor's pay:
A senator, a tycoon and a judge
To write a long report to file away.
They liked the human angle as a sop,
Inviting all the media to come in,
Posed with the "Baby Jesus" and as gifts
Left glosses, caveats, IOUs and spin.

And when this cast was finally called to rest
The farmhands laughed at everyone's expense
Watching the barman and the great and good
Grumbling about the rules of evidence;
And Peter liked a quiet gatehouse lodge
But when his Master came to stop the din,
The farmhands stared in wonder when he asked
The barman and the bigwigs to go in.

THE SHEPHERDS' TALE

The wind cut our clothes no matter how tight
as we dourly prepared for our tedious night.
We checked all the markings and counted the sheep
And prayed that our tiredness would send us some sleep:
I had almost dozed off when the sky came alive
With a noise that I thought we would never survive.

Unbearable light clamped our eyelids with fear
But an unlikely voice bade us be of good cheer;
The sheep were transfixed in an ordered array
As a Heavenly choir sang of birth on that day
Proclaiming Messiah was born for all men
And commanded us to go to Bethlehem.

We didn't have courage to argue the watch
But snatched at our bundles and went with despatch;
A baby was lying in a manger of straw
Radiating the light that we'd seen just before.
We gave gifts and went back to our flock full of fear
But we counted and found that we were in the clear.

There was slaughter of babes and rumours of kings
Which were linked to the birth and our strange happenings;
And we heard that they fled into Egypt at first
So we thought they'd been blessed but they seemed to be cursed:
But as boredom and mayhem went on year by year
The hope that we placed in that night disappeared.

I'm too old for the sheep so I like a good tale
And I heard that the baby had blazed a great trail
From the temple to trial and then to a Cross
And some say that he won a great triumph from loss;
That he was the Messiah who came down to earth
Then went back to where we had first heard of his birth.

I CANNOT SEE THE STAR

I cannot see the star,
The clouds are black like coal,
Not thunder from afar
But bombed and burning oil:
A child You were in Bethlehem
But mine is gone; remember him.

Born in a rubbled cave,
Swords glinting in the night,
I heard the groaning slave,
The desperate urge to fight:
So many children died for me
And I for them; remember me.

I do not want the tree,
The sparkling lights, the snow,
But Your nativity
And its red afterglow
To help me bear my infant's tiny cross
Through life; remember loss.

The candles and the snow
Are harmless revelry
But I cannot forego
Encounter with the tree
To live my Father's love who reigns above
For all; remember love.

DOES HE KNOW?

A baby is born
By prophets foretold;
A rose from a thorn
Left out in the cold:
Asleep in a manger
Of sweet smelling straw
Does He know of the danger
From Herod in store?

He smiles at the Lamb
The shepherds have brought;
Does he think: "I am"
Then banish the thought?
Does the gold draw His hand
To pinch Caesar's grim face
And does He understand
Why He lies in this place?

A toddler set down,
His exile is done;
Now in His home town
He contemplates fun:
But as he smells wood
In His father's small shed
Does He know of the blood
From the thorns in His head?

GAUDETE

In darkening days of penitence,
Before the turning of the years,
We look to make our recompense,
With new resolve and hopeful prayers:
The Lord's salvation is at hand,
Rejoice at His benign command.

Our souls awake in joyful praise,
The fingers of the rosy dawn
Glow in the East to give us hope
Of Judah's crowning, happy dawn:
Where there was sorrow now is praise;
Emmanuel for all our days.

Now may we walk at Mary's side
To help her cousin with the birth
Of one who will prepare the way
For God incarnate, here on earth:
Rejoice my soul, this cheerful day,
Rehearse your anthems, Gaudete!

LET US BE WITH MARY

Let us hide when Mary sees the angel come,
As she tells him softly God's will will be done,
And congratulate her when his light has gone
On the coming birth of God's beloved son.

Let us walk with Mary on the dusty way
And enjoy the news her cousin has to say,
We will gladly thank her if we're asked to stay
For the birth of John we'll meet again one day.

Let us ride with Mary through the falling snow
Down to Bethlehem where she's been told to go;
May we find her shelter as her birth pains grow
And then kiss her baby, as we love Him so.

LORD OF ALL

Our enterprises rise and fall,
What once was grand reduced to dust;
Ambitions falter and then stall,
Sometimes deserved, sometimes unjust:
But You are still the Lord of All,
The single point for faith and trust.

Our costs inflate, our savings shrink,
Our valued ways are cast aside;
Yet we still care what people think,
Less tied to wisdom, more to pride:
But with You we will never sink,
Brought homeward on the gentle tide.

Time after time we fail to learn,
As optimism fades to grief,
Admitting wrong, we freely turn
To You for counsel and relief:
But when the fire begins to burn
We flee, abandoning belief.

Through all these failures You still stand,
Our faithful God resolved to love;
For Jesus came at Your command
In human form Your love to prove:
And now the Spirit, as You planned,
Lives with us here, the Sacred Dove.

WHEN JESUS CRIES

When Jesus cries I hear him call,
He who seeks milk and human warmth,
Who could have been an earthly king,
With awesome power and matchless strength.

I hear the baby where I might
Be deaf to clamour from a king,
For I would never want to fight,
But would console that little thing.

God seems eternally in men,
And so this child gives much to me,
Of motherhood, a woman's grief,
A simple, smiled nativity.

OFFERINGS

I gave My Lord a manger for His bed,
A place where no-one else would lay their head:
I dared not think they would pay such a price
To bear a child amid the teeming lice.

I gave My Lord a lamb to pet and stroke
As tribute from simple and homely folk:
It would not grace my master's balance sheet,
Nothing but scraggy wool and stringy meat.

I gave a kingly ransom to My Lord
To furnish His escape from Herod's sword:
My subjects will be proud to know they paid
So much to spare a child and His maid.

I gave My Lord bright nails and rough hewn wood
And wept at how my sin was cleansed in blood:
But now our hearts within each other beat,
Our love and sorrow twined so sad and sweet.

JESUS, BORN BELOW

Jesus, born below all other,
Lowly lying in the straw,
Rich beyond all earthly measure
Yet a brother to the poor.

Jesus, blessed above all other,
Of the Father sent to earth,
You have given each Your blessing
Far beyond all human worth.

Jesus, love above all passion
Who in Passion saved our soul,
Such a tiny scrap of living
Died that we might be made whole.

LOOK KINDLY

Look kindly on these torn, bedraggled hills
For they have witnessed Heaven's mystery
Of angels singing of peace and goodwill,
A golden thread running through history.

Look kindly on this dank, infested cave
For it has housed the child of Heaven's grace;
No matter it reminds you of a grave,
For such will never be His resting place.

Look kindly on the tree that barely grows;
For it will be the tree of all our trees;
For it will bear the sum of all our woes
And yet the sum of all our victories.

WINTER LIGHT

When Winter light is overthrown,
Water to ice and branch to stone;
When light is flame on gleaming oak
Stars tears and clouds to cloak:
I know I need You then.

When bread and wine are sacrificed,
Manger to Cross and babe to Christ;
When flesh and blood quicken the soul,
Mother on donkey, Palmtide foal:
I think I know You then.

When stars and candles light the snow,
Shepherd's crook and camel's shadow;
When kings are puzzled by Your mother,
Straw meets gold and wood meets myrrh:
I need to know You then.

Sower of seed, pruner of vine,
Bread more than gold, myrrh mixed in wine,
Light of the world, Star of the Sea,
Starlight on snow at Calvary:
I know I love you then.

COME, JESUS, COME

Come, Jesus, come: we cry aloud
To bring new hope to weary earth;
We cannot help ourselves, yet know
Cruel death will follow wondrous birth.

Come, Jesus, come, our eyes are burned
As pride and greed shed toxic light;
We cannot help ourselves yet know
Angels will promise heavenly sight.

Come, Jesus, come: our ears are drowned
In choirs of selfish blasphemy;
We cannot help ourselves yet know
Your selfless grace brings liberty.

Come, Jesus, come: our hearts are sore
With beating to the idol's drum;
We cannot help ourselves but know
You are the one: Come, Jesus, Come!

REJOICE, REJOICE

Rejoice, Rejoice!
Let's all be merry
In candlelight,
Shine with the angels
This Christmas night:
Rejoice, Rejoice
With one voice.

Sing Carols, Sing!
Let's all be merry
In joyful might
Sing with the angels
This Christmas night:
Sing carols, sing
For our new king.

Lullaby, Lullaby!
Pray with the angels
Against the day
Purple in starlight,
Thorns in the hay:
Lullaby, lullaby
Babe, do not cry!

Praise, Father, praise!
Let's all be merry
In book and bell
Praise with the angels
This first Noel
With One voice
For our new king.

SYMBOLS

The Lord of salvation lay bloody and weak
As the wind raked the hillsides so barren and bleak;
The clouds in the night sky were lowering and grey:
A nail in the manger, a thorn in the hay.

The cattle were restless, the shepherds unsure
As they thought it demeaning to worship the poor;
It was they, not the sheep, who were likely to stray:
A lamb all-a-blemish, the crowd run away.

The purple-wrapped gifts of myrrh, incense and gold
Were the fruits of extortion and violence untold;
Did they visit the Saviour to pray or to prey?
A rent in the curtain, the king for a day.

Yet she saw the star and the light in the sky
As the angelic choir praised the Lord God on high;
And her own special angel had promised to stay:
A rose in the desert, the stone rolled away.

NEVER SUCH A MAIDEN

Never such a maiden trod this earth before
Never such a bounty offered to the poor
Never such a triumph over Caesar's law
Never such a Saviour lying in the straw.

Never such a servant watching o'er a king,
Never such a chorus, such a welcoming
Never such a levee as shepherds stumbling
Never such a burden as gold all glittering.

Ever is the promise born on that day was
Ever is the Gospel He said would come to pass
Ever is Our Lady queen of Christe-mas
Ever is our Saviour abandoned on the Cross.

A CANDLE FOR A MAID

Twixt crib and cross
Twixt straw and bark
Twixt holly and thorn
Twixt light and dark:
A candle for a maid
Twixt happy and sad.

Bound gloom and gold
Bound smoke and blood,
Bound myrrh and tomb,
Bound star and cloud:
A candle for a maid
Bound swaddle and shroud.

Raised love from hate
Raised plough from sword
Raised life from death
Raised flesh from Word:
A candle for a maid
Who bore Our Lord.

NEW LIFE

A new life is beginning
On this very special day;
We are thinking about Christmas
And Our Lord's nativity:
So prepare your hearts and souls as well as your houses
For a new life.

This is the time to remember
God's promise to the earth
That he would send a Saviour
And we are waiting for His birth:
So do not forget a gift for Him as one of the family
For a new life.

The new life soon beginning
Will be full of pain and love,
Of the Cross and Resurrection,
Then return to God above:
So thank God for His Son as our best and biggest present,
For a new life.

NEW BAPTISM

Thy people wait upon the bank
To be baptised once more;
Discounted now all fame and rank,
All that has gone before.

Those who have fallen on the way
By carelessness or craft
Determined to repent and pray
May take the healing draught.

Restored in Grace, revived in Word,
The water fills our soul,
And so we wait upon the Lord,
Whose birth will make us whole.

ADVENT AND CHRISTMAS

The roaring pressure of the world
Invades our inner space,
The greedy bedlam of the till
Reaches our quiet place:
In Advent when we need to wait
Most think that it is here
And as we walk to Bethlehem
Mangers are everywhere.

At this great time of penitence
We need more room to pray
And though we need to think and fast
We rush and feast each day:
The headlong dash for fellowship
Denies an empty place;
But in preparing for God's Son
We need more time and space.

THE GRAND VISTA

In one grand vista opening wide
We comprehend Salvation's scheme
Unfolding in the candle light
Of prophet's cry and exile's dream:
The promise of Our Saviour's birth
Has brought redemption into view;
What was projected in the Old
Will be constructed in the New.

We shall not mind the cold and damp
In contemplation of our hope
Based on the promise You have made
Not paradigm nor horoscope:
Yet we must strive for penitence
Amid the festive atmosphere
And keep our purple advent watch
Until the red of Christ draws near.

We see the distant star arise
And then familiar scenes unfold,
Of shepherds, choirs and massacre,
Of monarchs, politics and gold:
Yet, in our hearts, we know the Cross
Is standing on a distant hill;
And know that birth and death are joined,
Obedient to the Father's will.

THE COLOURS CAROL

Red is for our loving Jesus
Sent by God to live below,
Born in humble Grace to save us,
Cradled in the winter snow.

Blue is for his Virgin mother
Who received the Spirit's call,
Shared the pain of birth and passion,
Joy and mourning, Cross and stall.

Purple is divine and human,
Mary mingled with her Son,
Suffering as the way to Heaven,
Calvary for everyone.

Bright the star that lit His coming,
Bright the snow that lay so deep,
Brighter yet the clothes He folded
When he woke from Heaven's sleep.

THE DESERT ROSE

The waste will blossom as a rose
When our Redeemer comes at last;
His loving-kindness will disclose
The veiled promise of the past:
The exile of our sin complete,
We will return with joyful feet.

The desert will bring forth a spring
That we may be baptised anew,
A highway to our new born king
Will open for the strong and true:
Our strength and truth in holiness
Born of the Saviour we confess.

Where harps were silent they will play,
Where teardrops fell, laughter will rise;
We long now for that happy day
When Jesus in the manger lies:
Then we will dance and sweetly sing
A welcome to our new born King.

LOOK DOWN UPON THE DREARY STREET

Look down upon the dreary street
With special care this bitter night
And in self sacrifice retreat
From those found worthy in our sight:
May we, as agents, transfer hope
To those who lack the strength to cope.

May we bring light to dark despair
And spread warmth in the coldest place;
Temper the justice all must share
With mercy and the work of Grace:
May we behave as if we were
Those who are lost and do not care.

As we adorn the homely crib
And deck the tree with charms and lights,
May we be generous and not grab
And care for all our neighbours' rights:
May we be thankful for our homes
As places where our Lord may come:

But know His home is with the poor,
His strength most lavished on the weak,
That the new baby we adore
Is yet the servant all may seek:
May we be more like Him today
And smile where we would turn away.

THE CHRISTMAS SPIRIT

The Spirit celebrates Her child
In silver star and diamond snow
To let her raptured maiden know
How she is faithful, sweet and wild.

She is the sparkling
She is the song they sing
She is the news they bring
She is the star beckoning.

The Spirit celebrates Her Word,
Good news in harmony unknown
Which leads the awestruck shepherds on
To see the lamb that is their Lord.

The Spirit celebrates Her King
With gifts secured in rough-hewn wood
By nails of fatal brotherhood,
Sealed with the stamp of suffering.

The Spirit celebrates Our God,
Forged flesh from light's divine desire
Quickening all hearts with sacred fire
To know God in our flesh and blood.

STRANGER IN BETHLEHEM

Ladies: Look kindly on a maiden fair
Fear in her eyes, wind in her hair;
Will he be born before they come there?
Strangers in Bethlehem.

Men: There is no room for strangers here,
So full of care and full of fear,
Bide in that stable, not in here,
Strangers in Bethlehem.

All: Then in the darkness her child was laid
Straw-sharp; and troubled the gentle maid
Watched as the shepherds their tribute paid;
Strangers in Bethlehem.

All: Starbright and sunburst the break of day,
Fleeting repose in the scented hay;
Mayhem and flight as the soldiers slay
Strangers in Bethlehem.

Solo child: Infant divine but a child like me,
Here is my gift of a melody
That in my heart you will never be
A stranger in Bethlehem.

THE REFUGEE

Inspired by a Christmas sermon recounting the refugee child's offer to keep Jesus warm in the manger.

Shepherds come with angel song
– In the sky, in the sky –
Of rich for poor and right for wrong
– In the sky in the sky –
They bring a lamb in fear and wonder
Then run away to the dark yonder.

Princes come with cymbal clang
– Far away, far away –
With gifts of glitter, pomp and tang
– Far away, far away –
They half-kneel to a doubtful king
And drop dark hints of suffering.

A child, I flee from my war-torn land
– Woe the day, woe the day –
With only false papers in my hand
– Woe the day, woe the day –
The soldiers threaten him with danger
Let me climb into the manger.

LULLABY

Lullaby baby, lullaby boy
Dreaming of danger, dreaming of joy,
Which one will triumph, which one will fall?
Lullaby baby, Saviour of all.

Sharp was the message, sweet was the sting,
Angel in armour, announcing a king
Calm was the summons, clear was the call
Lullaby baby, Saviour of all.

Ecstasy blazing, fire in my womb
Widening wisdom, limitless balm
Poured on the humble from this peasant stall,
Lullaby baby, Saviour of all.

SING A SONG FOR THIS LADY!

Sing a song for this lady:
Hail thou fairest, virgin-queen!
Sing a song to greet a baby:
Hail the king of love serene!

Sing a hymn to greet the shepherds:
Peace, goodwill, to all the earth;
Sing a hymn to thank the angels:
Blessings for our saviour's birth.

Sing a dirge of kingly splendour:
Worship gold, myrrh and frankincense;
Sing a dirge for Herod's slaughter:
Rest in heaven, innocents.

Sing a song for this lady:
Halleluia! Mother, maid!
Sing a song to greet a baby:
Halleluia! Jesus, Lord.

SIMPLE PRAYER

No maid so pure as maid of earth
who bore the Spirit's child,
who knew the joy and pain of birth
in rapture warm and wild.

Who low before the angel bent,
then answered his stern call,
by humbly giving her consent
to bear the Lord of all.

Who spotless was in thought and deed
and loved her Joseph's children fair
mother of heaven and earth indeed
accept my simple prayer!

O WHAT STRANGE LIGHT

O what strange light
the virgin saw
an angel bright
within the door
with God's request
that her pure womb
should be the home
of Jesus blest.

O what strange light
the wise men saw
a star unlooked-for
lit the night
love out of lore
grace out of fear
the lion's claw
holds the lamb dear.

O what strange light
the shepherds saw
an angel choir
of dread and fright
proclaiming peace
goodwill to all
of our release
from Adam's fall.

O what a light
the baby's smile
this winter night
his birth we hail;
we love you Jesus
Saviour dear
look after us
now you are here.

IMAGE

The star sparked snow enholographed,
Nature's guile brought to celebrate
A child en-haloed in the straw
In decorously poor estate.

Yet I would take enphotographed
For stars and snow clogged clouds and clay,
A man enthorned in purple scorn
In torturedly rich array.

As snow is cold cheer enepitaphed
Stars map space into time's demands;
But God enfleshed in suffering
Unwinds a shroud with wounded hands.

WAR CAROL

The prince of peace cries for dying soldiers,
Tangled in war, who fight in vain,
A thorn in the straw scratches his finger
An innocent pang of earthly pain.

Shepherds in barren fields sense danger
And tense as unnatural light appears;
An enemy, then an angel, shouting,
A chorus that calms, then summons tears.

Kings running from guilt suspect the stranger
But sign a dark treaty to survive;
Their gifts of extortion round the manger
The price that each pays to stay alive.

Pain left at the breast of his sweet mother,
The baby can hear an angel sing;
Though sorry the gifts, he loves each giver,
The soldiers have found a new-born king.

WERE HE BORN IN SUMMER

Were he born in Summer,
Ripening fruit and hay;
Warmed by glorious sunlight,
Lit by golden ray:
Roaming sheep and cattle,
Camels on the way;
Joyful songs and laughter
On the longest day.

Were he born in Autumn,
Harvest gathered in,
Oil and wine of gladness,
Corn stowed in the bin:
Harvest celebrations,
Music at the inn;
Breezes stir and stiffen
As the sun grows thin.

(But) He was born in Winter,
Damp and mould the wall;
Peasants creased with shiver,
Cattle in the stall:
Rotting hay beneath Him,
Rough the shepherds' call;
Wild his mother's worry,
Snow begins to fall.

(And) he rose in Springtime
Blossom on the tree,
Hope in every flower
Life where death should be:
All the earth in rapture,
Love and ecstasy;
An unbounded future,
Life's eternity.

ASPECTS OF MOTHERHOOD

Virgin mother, sorrow sweet
At the lowly manger laid
All our hope; all sin repaid,
We lay our sorrow at your feet.

Humble mother, reverent peace
In the arms of Simeon lay;
May we depart, like his last day,
In confidence of our release.

Patient mother, suffering long,
Promise of a piercing sword,
Shadow of our saving Lord
In the pigeon's severed song.

Stoic mother, tinged with fear
As the guards with cowards' steel
Forced the prisoner to kneel,
May we withstand the torturer.

Weary mother, sky turned black,
Broken body, promise kept,
In pain He taught you to accept
His going so He could come back.

Glorious mother, full of grace;
An earthly child and pain transformed
Into a universe informed
With the Grace your womb embraced.

CHRISTMAS SONNETTE

A snowflake impaled upon a thorn,
A diamond of ice in a shell,
A season as close to grieving
As withering flowers on a grave;
A baby exiled in a cave,
A tousle of hay for Noel,
A scenario as far from believing
As shepherds seeing Messiah born:
A blossom of blood on a manger,
A ruby of blood on a tree,
A season as full of danger
As an Imperial decree:
Now see Calvary in the snowy night
And the open tomb in the stable light.

WERE THERE NO SNOW

Were there no snow,
Although we love its glitter,
Were there no shepherds
To hear the angels sing,
Were there no wise men
With presents bright and bitter,
God is our God
And Jesus is our King.

We love our crib,
Its holy ritual,
Hopeful, nostalgic,
Iconic and naive;
But were the comfort
Of the childlike visual
To be retracted
We would still believe.

Were there no star
Shining above the stable,
Were there no stable
With cattle standing by,
Were there no history
But a pious fable,
Jesus was here
And reigns with God on high.

Whatever fails
We live within the Father,
Whatever strikes
We live beside The Son,
Whatever palls
The Spirit never leaves us,
Nothing divides
The Godhead, Three In One.

THE BEAR, THE PEACOCK AND THE LION

The growling bear scratches testily in the snow,
The nervous peacock twitches in the Himalayan glare,
The lion of Abyssinia stretches his sandy roar:
Something mysterious is happening in the restless air.

A polymath scratches hastily through old texts,
A nervous priest reads auguries at a gleaming altar,
A prophet wrestles with falsehood's rampant history:
Then each in his own way sees a new star.

One almost loses a stallion in icy water,
The second wrests an elephant from a murderous defilement,
The third makes wily alliance with a camel of no grace
To where the ley lines correspond with the firmament.

A tiny child dozes gently in the straw,
The nervous mother reaches out to greet the dusty Kings,
The whole of the delegation kneels on the earthen floor
And offers gold, incense and myrrh;
Integrity, priesthood and suffering.

OUTBACK CAROL

I found a manger
In Bethlehem's outback;
I felt a hunger
For something in their looks;
I spied the danger
From the dust of distant trucks;
I was a stranger
But I seemed to bring them luck.

The tiny Saviour
Was sleeping in the shade
Of a makeshift shelter
That His father made;
His mother hovered
Quietly afraid;
She heard the whispers
Of a desperate raid.

Koalas gathered
In a nearby tree,
Kangaroos bounded
To see what they could see;
A wombat staggered
In sunlight blearily
And they all worshipped
The infant reverently.

A helicopter
Hovered then flew away.
They had all vanished
By the break of day.
The Baby Jesus
Was carried far away;
The Southern Cross glittered
To mark where He once lay.

COME, LET US SEE THE NEW BORN BABE

Come, let us see the new born babe
And be like shepherds, down in Bethlehem;
Angel-song fading, carrying a lamb
To play a half sad pipe to help Him dream:
Sleep sweetly, babe, Your hand upon its fleece
For You, unblemished Lamb, must bring us peace.

Come, let us see the new born babe
And be like monarchs paying compliments;
Yet all our best in gold and frankincense
Ends in myrrh's tears, the tomb's tart eminence:
Sleep sweetly, babe, there is no cause to cry
Until, disarmed, You cry in victory.

Come, let us see the new born babe
And be like children with our bright, crib prayers;
Those simple, innocent desires
Which move Your mother's eyes to happy tears:
Wake now! And take Your comfort at the breast
That we may take ours in the Eucharist.

THE FOUR KINGS

I gave him gold,
That wondrous, infant Lord
But might have known the fate it had in store;
To be the kernel of his mother's hoard
Until it reached the desperate and poor:
I hear the whispers as I slowly die
That he took suffering for His royalty.

I gave him incense
To make a lifelong prayer
Because the star said he would be a priest;
Its sweet smoke rising in the sullen air
To signify the coming of a feast:
And as I kneel to pray with him this night
I see that star grow black and then glow bright.

I gave him myrrh,
A symbol of His fate,
A gift for one whose sorrow I could see;
And whose trajectory has been both steep and great,
Ending in sudden death, then victory:
For as I read despatches from the West,
They say His followers have been supremely blessed.

I gave him manuscripts
From sources rare,
Of Greek enquiry and Persian trance
To reinforce the Hebrew love of prayer
And help His messianic cause advance:
And as I cast my final horoscope
I see Him risen, born to bring us hope.

MAGNIFICAT

My soul lives in the greatness of the Lord
And rejoices in the Grace of my salvation
For He has rescued me from servitude
To be His servant queen for every nation.

All peoples for all time will call me blest
Not for myself but folded in His fame
Which unites heaven and earth in one dimension
To celebrate and glorify His name.

His strength and goodness compass all who love Him
Beyond the ancient strictures of the Law;
His mercy heals all earthly degradation
To liberate the sinful and the poor.

All earthly powers will crumble at his coming
And justice will prevail in every land;
The hungry will be fed, the weak will flourish,
The prostrate will receive the strength to stand.

The promise given to His chosen people
Extends to all the people on the earth
And I will serve them through my intercession
Because He made me fit to give Him birth.

WERE HE BORN NOW

Were He born now
The wind would have its moan,
The rain lash,
The thunder growl,
The lightning flash:
No sparkling snow
Hardening against the blue,
No frost bite,
No ice crack,
No clear night.

No sun nor star
But creeping, speckled smoke,
The flash flood,
The brown fog,
The blighted bud:
Yet He would reign
From tenement or slum,
The same Son,
The same Cross,
The same Tomb.

THE INFANT KING

PROCESSIONAL

Prepare to crown the Infant King:
Though we wear purple at His Court
The time of reckoning is short,
His royal star is beckoning:
Prepare to crown the Infant King.

Prepare to meet the Prince of Peace
And pray that Bethlehem may see
The fruits of his nativity,
That zeal for earthly power might cease:
Prepare to meet the Prince of Peace.

Prepare to greet our Little Lord:
Emmanuel for all our days,
The joyful centre for our praise
Of life renewed and hope restored:
Prepare to meet our Little Lord.

Prepare to love our Blessed Child
Whose humble birth was made complete
When He washed His disciples' feet
Who suffered Him to be reviled:
Prepare to love our Blessed Child.

Prepare to tread the Pilgrim Way
From Jordan's Bank to Galilee,
From Bethlehem to Calvary,
From Advent until Easter Day:
Prepare to tread the Pilgrim Way.

I. GENESIS 3

For Eden's tree Calvary's cross;
For what man knew Our Lord knew pain:
The tree of life, the tree of death
He gathered what the world had sown.

For honeyed apples bitter gall
For what man gorged Our Lord took none:
The food of life, the food of death
He offered what the world had strewn.

For comely Eve a virgin pure
For what man ravished Christ was born:
The seed of life, the seed of death
She cherished what the world would scorn.

For Satan's serpent Yahweh's lamb
For what man flattered He was torn:
The source of life, the death of death;
He conquered what the world had hewn.

II. GENESIS 13

And through the smoke of wood and lamb
 The angel spoke to Abraham:
 "Those who can count thine shall be none
 By reason of thine offered son."

 "Thy race as numberless as sand,
 Thy fortune in the Lord's command:
 And when thine think that I am gone
 Thyself and I shall share a son".

III. ISAIAH 9

Ash glows like blood in the withered grass,
 Smoke claws like death at the city wall;
 And yet we fear more than night's distress
 To see Isaiah's prophetic gloom befall.

For fire the sun
For smoke a stream
For darkness light
Our Lord supreme.

But dawn uplifts our dismembered hope,
 The sun sets fire to a sparkling stream;
 And we pray Yahweh His word to keep
Of milk and honey in Isaiah's troubled dream.

For fire the sun
For smoke a stream
For darkness light
Our Lord supreme.

Sunset like blood but we live in light
The Daystar shines in our hearts where we knew fear;
 And we are wrapped in a tranquil night
Knowing our Blessed Saviour's birth is near.

For fire the sun
For smoke a stream
For darkness light
Our Lord supreme.

IV. ISAIAH 11

A shoot escaped from frost will surely grow
To flower in unimagined shape and hue
Changing the way we measure what we know,
Surpassing in our lives what prophets knew.
Cattle with lions, lambs laid down with wolves,
Leopards with kids and poison asps grown mild
Shall not emerge as our worn world evolves
But burst anew, made trivial by a child
Who by the Spirit and of a maid was born,
Whose comfort past all comfort shall assure,
Whose wisdom past all wisdom shall hold sway:
Then shall all earthly power be put to scorn,
The meek raised high, abundance for the poor,
All things e'er known transformed on that bright day.

V. LUKE 1

An angel tall and bright
From heaven did
appear
In all his power and might
He filled a maid with fear

> *O angel so bright,*
> *O maiden so pure*
> *A soul full of light*
> *A servant so sure.*

"Fear not, O gentle maid,
God wills a Saviour Son
If you will give Him shade
Within your virgin womb."

> *O angel so bright,*
> *O maiden so pure*
> *A soul full of light*
> *A servant so sure.*

"I am the Lord's" she said
"May His sweet will be done.
His servant, yet a maid
I shall bring forth His son."

> *O angel so bright,*
> *O maiden so pure*
> *A soul full of light*
> *A servant so sure.*

Then was Her calm restored
That spot so bright grew dim,
She felt her little Lord
And knelt to worship Him.

> *O angel so bright,*
> *O maiden so pure*
> *A soul full of light*
> *A servant so sure.*

VI. LUKE 2

Thy starlit throne a manger bed
One star alone a heavenly thread:
Angelic praise soft cattle lowing
Their quiet ways the prophets bowing.

Eternal might an infant's sleep,
The darkest night nearest to deep,
Yahweh's disdain a baby crying
His mother's pain a saviour dying.

The crowded inn an empty cave
Adam's first sin a vanquished grave:
The weak whose cries hailed His descending
Shall with Him rise, world without ending.

VII. LUKE 2

ike coal in light, the sky so bright
　　Our sheep froze fast in fear,
　　　While thunderous sound boomed all around
　　So deep and yet so clear:
　"Glory to God" the spirits said,
　　"Good news for all the earth"
　Which seemed to be a prophesy
　　About a local birth.

Stirred with goodwill we ran downhill
　　To find the promised child
Laid in the straw, that infant poor
　　Just as the spirits told:
Bending the knee His majesty
　　Was never so well hid;
Face to the ground true peace we found
　　Just as the Spirits said.

VIII. MATTHEW 2

What treasure can we offer to our king
Who, seeming weak, is Lord of everything?
No Tarshish hold
Of Ophir gold
Could ever please, for all its glittering.

What worship can we offer to Our Lord
Who gave Himself as the Incarnate Word?
No reverence
Of frankincense
Could ever praise, for all its sweet accord.

What sorrow can we offer for this cor'se
Who gave Himself for us without remorse?
No bitterness
Of myrrh's caress
Could ever mourn, for all its sad resource.

IX. JOHN 1

Smoky and faltering I shine
 Upon a babe so newly born,
 And with the new light my powers decline
As He awakes on His first dawn.

Shiny and glistening the star
New born shines over Bethlehem,
But I am luckier by far
Because I shine so near to him.

O faltering lantern, beam so low,
Shining upon that sleeping face:
Who came for us that we might know
In flesh the God of endless space.

CODA

A dancing snowflake calms a bleating lamb
A star shine cheers a weary king
A berry stores the blood unshed
In the beginning.

An angel sets alight the secret sky
A chorus makes the whole world sing
A mother hums a lullaby
In the beginning.

The snow melts and the star declines
The blood bursts in the gloom
An angel bears a golden cup
On the darkest afternoon:

A lamb starts awake in a golden haze
An angel greets the risen king
A mother feels her womb ablaze
In the beginning.

VOLUME II

NO LAMB SO BEAUTEOUS

2013

PREFACE TO VOLUME II

Whether or not it is a late flowering or a harbinger of new growth, the abundance of contemporary church music on both sides of the Atlantic is as startling as was its late nineteenth-century English revival. With the rise of popular church music in the late 1960s it appeared as if the tradition from Stainer to Britten might be at an end, but we are now enjoying a period of substantial and eclectic output from jazz to the crypto-medieval. Nowhere is this variety more evident than in the range of new Christmas music from, to name some leading carol composers, John Rutter, Andrew Carter, Morton Lauridsen, Malcolm Archer, Bob Chilcott, and Eric Whitacre.

Yet, no matter how skilled the musician, there comes a point at which new lyrics are required. Many of the most popular carols already have such traditionally favoured settings that any new attempt frequently sounds like novelty for its own sake; and as the years go by an ever greater number of lyrics receive what become classic settings where novelty is hard to imagine. For example, there is the case of Harold Darke's setting of Christina Rossetti's *In the Bleak Midwinter* which far surpasses the earlier and, in its day very popular, Holst setting and although there are hundreds of settings of *O Magnum Mysterium* it is hard to see Morton Lauridsen's recent setting becoming outmoded.

If the carol setting tradition is to survive, new lyrics are wanted as the old become ever more associated with one or two settings. I first became aware of this need when learning Howells' *Here is the Little Door* and ever since it has been my hope to offer contemporary composers new possibilities.

In this second collection of Christmas poetry I have quite deliberately followed the broad pattern of the first, laying out my pieces in approximate chronological order, starting and concluding

with a set of pieces suitable for an extended work for choir and soloists. Readers might also notice a bias towards the archaic which, I believe, matches the zeitgeist for an approach nearer to the Medieval than the Victorian.

Meanwhile, although I hope that composers will contact the publisher if they wish to set any of these pieces, I am conscious that the much greater audience will be the general reader seeking a different perspective on what has for many become a somewhat hackneyed festival which is a pity when the birth of any child, but this child in particular, is so special.

Kevin Carey
Hurstpierpoint, West Sussex
Trinity Sunday 2013

NO LAMB SO BEAUTEOUS

i.

The whole world groans in anguish for the day
When our Creator's promise will be kept
That we, unbound from Adam's bondage may
Become, once tarnished vessels, cleaned and swept.
The days grow darker outside and within,
Oppression's burden crowned with anxious hope,
Our cheerfulness grows brittle, sharp and thin,
The best that we can manage is to cope.

Yet that which is most brittle shines most bright,
Its glittering teases as the day draws near;
Redemption, once miasma, comes in sight,
Impatience knuckles loose the bonds of fear:
Lord Jesus come, come quickly down to earth,
Dispel our gloom with infant cries of peace,
Reward our fickle patience with your birth,
Fulfil the long-held promise of release.

ii.

Against the darkening Winter wind
A donkey slithers down the stones
Sharpening her pain,
Sapping youth's vibrancy,
Reducing her to aching flesh and bones.

Lamps lure the beast and stay the pain,
The spitting welcome brings relief;
Callous disdain,
Equivocating pregnancy,
The outcast straw, strewn roughly, softens grief.

Low cries the child, too weak for lust,
Too slight to bear the sloth and crime,
Born to sustain
Incarnate mystery:
The shadow of the Cross falls back in time.

iii.

So far away the angel's message sounds
As restless soldiers tramp the market place;
I wonder if I dreamed that miracle
Or harbour a delusion of my grace.

Perhaps it is the fire in my womb
Extinguished by cold terror in my breast
Which assuages and torments me by turns:
But for the moment, Lord, just give us rest.

Enough of introspection's ebb and flow,
However formed and born, he is my son,
I am the only mother that he knows,
And we will finish what we have begun.

iv.

Not like the shepherds we have heard of Greece,
From travellers' tales,
Lush grass and blooming maidens
Gaudy of attire and gifted
In the Terpsichorean art:

Ours is a parched life, sparse
And outcast of the supple softness of caress:
Bound to our spindly sheep and yet
We love them as if their fleeces
Were fit for palaces.

But Grecians never heard such thunderous choirs,
Of angels far surpassing their mean lyres;
No messenger of Zeus has ever brought,
Such joyful news to meeting house and court:
No lamb so beauteous, worthy to adorn
The crib of this sweet child, Messiah born.

V.

Mysterious tidings billow round the inn,
Shepherds are feted then despised;
The subjects of their gossip darkly fled,
The angel vaulted hope unrealised.
What of mysterious omens in the sky?
Hope always vanquished by despair,
The bane of drudgery ruts palsied breasts
Dissolving promises in fetid air.

Insinuating rumours breed mistrust;
What is the crime? Who is to blame?
The questions are redundant as the guilty
And the innocent will be treated just the same.

vi.

His eyes light with the glitter of strange gold
As agents tally cargo at the gate;
But darken as his courtiers relate
What prophets and these men have both foretold:
Yet cunning glues him to his fragile throne;
His undeceiving smile sends them away
Knowing the court he promises to pay
Will be to himself or will not be done.
They drop their gifts in haste and fluff their lines
And, well advised, shun Herod's courtesy;
The slaughter was not foretold in the signs,
Nor why the child was worth such cruelty:
But wisdom's pride and arms which make a king
Will be transformed by this child's suffering.

vii.

'A Life' confined to childhood yields small truths;
The manger teaches but the Cross restores;
God in our flesh breaks into time and space
But victory over death destroys all laws.

For we will die in Christ awaiting him
To end this world and heaven, to re-create
Our selves complete in corporate harmony
With God and humankind in perfect state.

THE APPLE

Adam lived in a garden
And it was fair and green;
And God gave him a maiden,
The fairest ever seen:
And all that marred their pleasure
Was a shining apple gold
That they were not to eat of
As our Creator told.

But as soon as they had eaten
The sweet to bitter turned;
And God stern said to Adam
Your victuals must be earned
And as for you, so tempted,
New life will bring you pain
And between you and the serpent
An issue will remain.

But slithered up the serpent
And said to comely Eve,
This fruit will never harm you
But bless you, I believe:
For you will have the knowledge
As adults to behave;
And remain as children
As God says he would have.

But then was born a maiden
Spotless and fair as Eve,
Visited by an angel
Who said she would conceive:
And give to us a saviour
True God and yet true man:
To free us of the apple
Where our sorrows began.

BIBLE DANCE

Adam for an apple paid with every human life
Eve for eating paid in pain for every bearing wife:
Abraham who gave his son was chosen of the Lord:
Moses led his people out across the Red Sea ford.

Isaiah promised after pain the people would be free
Through a king he said would spring from the root of Jesse,
Cousin John at the Jordan said make the crooked straight
Here he comes, the Lamb of God, for whom all people wait.

He was born in Bethlehem where Jesse had his flocks
Shepherds came who heard his fame, warmed by the ass and ox
Angels bright that starry night proclaimed goodwill to men
But infants were the first to die for what wise men had seen.

Maiden servant killed a serpent down in Bethlehem
Apple tree to Calvary the wood was yet the same
God, Adam and Abraham at last all shared a son
And Jesus Christ the source of life ended what they began.

SALVATION'S DAM

The Baptist cries against the wind,
His rough words blown back in his face,
He sees the inward, sinful mind,
They see his obvious disgrace.

And were he to walk down our street
Shouting aloud our faithless sin,
The priest and wardens would retreat,
Determined not to let him in.

But he it was who saw the Lamb,
Making himself the first but least,
Breaching the sacramental dam
To watch salvation being released.

MARY WAS DREAMING

Mary was dreaming of her love,
Fitfully working at her loom,
Blinked as the sun which glared so bright
Flooded her dark and tiny room.

When she looked up, an angel stood
Towering above her frightened head,
"Mary, all hail, the blessed one,
I come from God," the angel said.

"You have been chosen of your race,
Infused with grace to bear a son,
He comes to save the poor and weak
He is the Lord, the holy one."

"God's will is mine," the young girl said,
"I am his handmaid, mine his womb."
"Farewell," the angel, parting, said,
Leaving her in the darkened room.

THE BAPTIST CRIES

The Baptist cries, the Virgin prays,
Life quickens with Isaiah;
Eyes bright, we count the shortest days
Waiting for the Messiah:

The purple of our penitence
Confronts our sinfulness
Threatened by scarlet opulence
Plunging into excess:

Darkness alive with candle flame
Lit by the Spirit's fire;
Our Saviour born in seeming shame
Child of sublime desire.

O COME EMMANUEL, COME!

O come, Emmanuel, come!
Our vigil is too long,
What we began with flame
Is now a sad song:

The stately Advent road
Is cluttered with the mess
Of human appetites.
Be our excess.

That clear but distant ray
Is fogged with earthly greed,
And with each desperate day
You are our need.

Their baby is the end;
Christ's wreath will be a crown
Of thorns then heavenly bliss;
Emmanuel, come down!

STROLL-ALONG DONKEY

Stroll-along donkey
Who are you carrying today,
Stroll-along donkey,
As you plod your weary way?
The lady with her load
Is slight to carry
But stroll-along,
Do not hurry!

Stroll-along donkey
I know the hay is thin and worn,
Stroll-along donkey,
At least the stall is clean and warm:
The baby in the straw
Is extraordinary,
But stroll-along
Do not worry.

Stroll-along donkey,
So Egypt took you by surprise,
Stroll-along donkey,
Look at the fear in their eyes:
The baby on your back
Is extraordinary,
So stroll-along donkey
Hurry! Hurry!

FOR OUR LITTLE LAMB

Light a candle
For the window
As a signal
Of our yearning,
For our little lamb
Before the year's turning.

Cut the gifts for
Those with plenty,
Fill the stockings
Of the empty
For our little lamb
So poor and so lowly.

Say a quiet prayer
For the gentle
But eschew the
Sentimental
For our little lamb
So meek was slaughtered.

THE LOVER

I sat on a rock with the wind blowing wild
And saw a young girl full ripe with a child
Pass by on a donkey with the night closing in,
Her husband so old that I thought it a sin.

I carried a flagon for the company's cheer
And heard a loud groaning which filled me with fear;
I peeped through the slats, and a baby I spied,
That young girl looked down and the baby he cried.

I walked through the night time to rid me of woe
For my sweetheart had sworn that she loved me not so;
And angels sang comfort for such as me poor
And I thought of my maiden; and our love evermore.

HOW DARK THE SKY

How dark the sky,
How bright the star:
The soldier's tread,
The tavern's roar,
Destined to praise
A child so poor,
Lord Jesus born
for us all.

How dark the sky
Shot through with light:
The shepherd's dull
And angels bright
Worship the child
On this great night,
Lord Jesus born
for us all.

How dark the sky,
The comet's tail
Draws camels onward
Like a sail
At God's command,
They cannot fail
Lord Jesus born
for us all.

NO HALO

No halo but his freezing breath,
The star shine was the only light;
In birth so very near to death,
An outcast on that Winter night.

The grizzled shepherds, bent and thin,
Not lusty youths of rustic charm,
Their pipes a melancholy din,
Breaking what sense there was of calm.

The kings brought torment with their gifts,
Herod's scent clinging to their hair,
His words encoded in their shifts
From reverence to abject fear.

But is our welcome, bright and shrill,
What he would want, who lay so low?
And are our tidings of goodwill,
A parody of long ago?

SILENT NIGHT

1. Silent night! Holy night!
See their lone vigil bright:
See the holy and intimate pair,
Lovely child with curly hair;
Sleep in heavenly peace!

2. Silent night! Holy night!
Son of God, pure delight:
Love and Laughter illumine his face,
Stunning us with his saving grace
From the hour of his birth.

3. Silent night! Holy Night!
Graces our earthly plight:
From heaven's golden heights his birth
Pours God's mercy on the earth:
God in Jesus seen!

4. Silent night! Holy night!
Father's love, power and might
Given today to the human race
In the arms of a child's embrace:
Jesus for the whole world

5. Silent night! Holy Night!
Ancient plans put things right:
We are freed from the exile of wrong
Foretold throughout the ages long:
Saviour of the whole world.

6. Silent night! Holy night!
Shepherds first saw the light;
Sounding forth both near and far
Heard the angels' alleluia
Our Saviour Jesus is here!

WHEN JESUS CAME

Over the hills came the wind with a sweep,
Ruffling the hair of the boy in his sleep,
Counting a fortune of heavenly sheep
When Jesus came.

Standing before him an angel in white
Woke him from sleep with a terrible fright:
Unearthly voice and clothes unearthly bright:
When Jesus came.

"Don't be afraid, I bring news of a birth,"
Good news for all of goodwill upon earth
But, most of all, pilgrims who suffered a dearth
Before He came.

Smiling, she beckoned them to take a peep
At their saviour lying before them asleep,
King of creation, including the sheep
When Jesus came.

SLEEP, LITTLE DARLING

Sleep, little darling, till the dawn,
Now that the shepherds' song is done;
Snuggle the lamb to keep you warm,
Joseph will keep you safe from harm.

Sleep in the straw, so sweet but rough,
It is the best that we can do;
Life will be turbulent enough,
If what the angels say is true.

Yours is the glory, ours the pain,
Worthy when you become a man,
Until you seek my breast again,
Sleep, little darling, while you can.

SING NOEL

Sing Noel
Ring the bell
News to tell
All is well.

Angel shows
Spirit knows
Baby grows
Heals our woes.

Sing Noel . . .

Shepherds keep
Flocks of sheep
Take a peep
Babe asleep.

Sing Noel . . .

Wise men see
Christ to be
Reverently
Bend the knee.

Sing Noel . . .

COME AND SEE!

Once on a day
Our Saviour Christ was born:
Come and see! Come and see!
Born in a stable
Cold and all forlorn:
Jesus is born
For all today:
Come and pray! Come and pray.

Once on a night
The shepherds heard the word:
Come and see! Come and see!
He is the good news,
He is Christ the Lord:
Come and see! Come and see!
Jesus is born
For all today
Come and pray!
Come and pray.

Always forever
Christ was born for us:
Thank the Lord! Thank the Lord!
Hung on the cross
And yet victorious:
Thank the Lord! Thank the Lord!
Risen, triumphant,
From the straw!
Alleluia!

A CHILD OF BLOOD AND FIRE

Along the rough and winding road
A laden donkey bears its load
Of mother and Messiah;
A child of blood and fire.

Within a dark and musty shed
A manger never meant as bed
Bears God incarnate
In his helpless state.

Yet scrawny sheep in scrawny fields
With scanty fare and scanty yields
Are fat with jubilation:
And loud with celebration.

Beneath a brightly shining star
The weary scholars from afar
Are bent on admiration:
But bend in adoration.

FLEETER THAN DONKEYS

Fleeter than donkeys plod,
Faster than shepherds, I
Am the first to see God,
Out of the angel sky.

Sometimes the glow in coal,
Sometimes the cooing dove;
Wrongly described as soul
When I am active love.

Shimmer the sudden star,
Signal the angel song,
Gone from the seminar
Into the mess of things gone wrong.

Father and me in Christ;
Flesh in the Trinity,
Unable to resist
The love of humanity.

THE CHRISTMAS SHOW

There is no snow to cloak the barren rocks,
Blurring the outlines of the scrawny flocks;
The wind shifts from a whisper to a shout,
The rain seems not to pacify the drought.

He shall not want that picturesque display
Of passing beauty, soon grown thin and grey;
But songs of sheltering shepherds at the gate,
Grumbling at wind and weather as they wait.

For nature's core is not the high romance
Of peak and glade, but human circumstance;
The beauty of his birth lies in its mess,
The ingrained human trait of incompleteness.

Of craft and artifice, there was the trough,
Where he was laid in coarse but wholesome cloth,
The star that hovered over Bethlehem,
The nearest form of brightness to a gem.

But can we bear the lash of wind and rain,
His cold so close to death where he was lain?
Or shall we keep the sheen of perfect snow,
The sentimental, pretty Christmas show?

DIFFERENCE

Like the sun when fog has cleared
Like young love that knows no blight
You are new wine, the cup that cheers
You are the candle in the night.

Like an unflawed amethyst
Like a lake both deep and clear
You born lowly are the Christ
Who feels our pain and knows our fear.

Like the Mona Lisa's smile
Like Beethoven's uncorked zest
Change more disruptive than style
Rapture that could not be guessed.

You are freedom newly known
You are news uniquely good
The only perfect thing we own
Our God made known in flesh and blood.

ASKEW

Ragged myrtle hedge,
Icicles askew,
Snow blurring the edge,
Snow blurring the view:

On Christmas night
Of star-shine bright:
Church bells ringing,
Angels singing.

Shepherds warbling pipe,
Frightened, scattered sheep,
Shuffling in the street,
Nobody can sleep:

On Christmas night . . .

Grumpy camels pad
Through the baking sand,
Careworn kings press on
Through the hostile land:

On Christmas night . . .

Red and purple meet
Lit by pagan light,
A baby's birth brings joy
On a Winter's night:

On Christmas night . . .

A STRANGE STORY

Whoever heard of a king in a stable?
Unless, of course, he was patting his horse;
And whoever brackets shepherds with angels?
Well, perhaps you may if you're writing a play.
And when have kings knelt at the bed of an infant
Unless they are settling dynastic affairs?
All these improbable things in one story
Told down the ages for two thousand years.

A king in a manger surrounded by shepherds
Is as wild as a king nailed to die on a cross;
And a king in a hut sought by exotic strangers
Is as strange as a gift from a corporate boss;
But of all of the strange things told in Jesus' story
The strangest of all is God's life on our earth
To express solidarity with our dilemmas
In spite of the fact that we put him to death.

ON CHRISTMAS NIGHT

A baby is sleeping in the tinsel,
A candle glows weakly in the light,
The sleigh bells are drowning out the angels,
On Christmas night.

An orphan forgets his life of squalor,
A ragged girl looks for something bright,
A foreman gives out an extra dollar
On Christmas night.

A prisoner feels starlight in the darkness,
An exile is home and all feels right,
The world for a moment is united
On Christmas night.

SHEEP

The notes of a thin pipe falter
As the dull evening meets its end;
Brush for a make-shift shelter
Not a match for the cruel wind:
The spindly sheep stand huddled,
Grown tired of the withered grass;
The men and their flock all anxious
For the threat of the night to pass.

The voice of an angel pierced their sleep
And they woke in a blazing light;
"Good news," said the angel, "Goodwill to all men,"
But his comfort filled them with fright:
Then they heard a choir singing
With a sweetness unknown before,
And they saw the lambs all dancing,
And they praised God for what they saw.

The baby laid in the manger
Hardly looked like an infant king;
But their simple faith did not waver
As they made him their offering:
Their puzzled leader marvelled
That the fleece was so rich and deep;
The good news had clearly favoured
The poor shepherds and their sheep.

SNOW

Cruel as the snow is beautiful
 The virgin carpet spreads before the virgin bride,
Cold as the wind is clinical
 It grimly ransacks treasured warmth from every side:

Yet deep within her heart she feels the pain
Of labour, love and loss she can't explain.

Harsh as the inn is welcoming,
 The outcasts pay above the tariff to get in;
Bare as the cave is comforting,
 She knows her first great love is destined to begin:

Yet in the darkness of the earthly hour
She feels her love, the Spirit, in His power.

So late the Spring this year,
So high the angel mission sent to earth;
So wild the joy of her Elizabeth,
So strangely comforting her nephew's birth:
And now the coldest Winter ever known
Has left her here alone;
But for God whose Son she has just borne
And the Spirit filling her this happy morn.

Close as the star is distant,
 Its steady pulse beats with the heart of Heaven above;
Red as the rose is white,
 It beckons with the purity of new found love:

Yet even as she wraps him in a fleece,
She knows this is the dying of her peace.

DESERT SHIPS

The desert ships in file
Drawn by the comet's tail
As if it were a sail
Pad over waves of shale
As if God speeds them well.

What strangers bear
These cargoes rich and rare
Bought with craft and fear,
All death and fire,
In taverns drear?

A brooding king enquires
Of these strange seers,
Enforced ambassadors,
The fate of his desires
And half-known fears.

Oh! The relief of worship,
The fear of the return!

Unplighted troth
Unleashes murderous wrath:
Blood on the exile path:
Childless as Ruth,
They await a higher truth.

CHILDREN

A child escaped from Herod's sword
Did not escape the Roman tree;
Thus was the journey of Our Lord
From Bethlehem to Calvary.

And as we see him lying there
Or as he watches from the cross,
How far do we extend our care,
Repent the deed, make good the loss?

In every country children cry,
Abused and starved, tortured and killed:
No code for Christians to live by,
Not why He died, not what He willed.

Then for the Manger and the Cross
Strive to set every child free:
Love without a sense of loss
From Bethlehem to Calvary.

NATURE

The foxes brushed the dusty road
To smooth the path the donkey trod,
Bearing its light and precious load,
The mother and the son of God.

The shepherds, wakened by their sheep,
Heard angels' voices in the sky;
The cattle warmed the child in sleep,
Lowing a simple lullaby.

The camels signed a solemn truce
Of non-aggression with the kings
Who, solemnly, renounced abuse
And sighed for previous sufferings.

The ant, the lion and the dove
Gave thanks to Jesus in their way
But do I recognise his love
And offer mine to him each day?

PROPHESIES

Here is the most comfort that we can afford,
Rough flax for a peasant, not silk for a lord;
Let me lay you down quietly in the sweet hay
Which is not what the angel appeared to say.

Here are five fine shepherds enjoying their sport,
Music fit for a tavern but not for a court;
They have brought you a lamb from the flock's finest ewe
And yet it is tiny and weak just like you.

Here are seven grave sages who have followed a star,
Which has led them, they tell me, to just where we are:
They left their fine presents and fled in the night,
And we will be leaving as soon as it's light.

Here are eight fierce cavalry blocking our way,
At least they are Romans, not in Herod's pay;
And the more I reflect it seems Simeon was right,
And the angel seduced me with heavenly light.

Here are seventeen furlongs before the next bend,
The road of an exile seems never to end;
And if what Simeon told me is faithful and true,
What has happened to me will soon happen to you.

GOING BACK

Christmas Day 2012

Respectively intense or watered down,
Nostalgia flares to ignite worn desire,
As the outcast, lonely and depressed
Strain in the cold to boost the threadbare choir,
While the rational, who know that they know best,
Drink glühwein round an artificial fire.

The unfinished story of our Saviour's birth
Whispered by slaves in catacombs below
Imperial Rome, reached its imperial height,
Built on Victorian pomp and snow on snow,
Has morphed into its pagan origins,
Leaving a puzzling Christian after-glow.

And we, against the flow, move back in time
Towards the rebel church he came to found,
Of radical upheaval and reform,
Good news emerging from the underground,
Affirming not conforming, marginal
Because of what we say, both heterodox and sound.

POST-EPIPHANY CAROLS

i. Dreams

When Joseph dreamed
He heard a sword shout
And felt the blood spurt
Over Ephrath;
And then he saw himself
A nomad
Beside a pyramid
Conning hieroglyphs.

Lulla, lulla, lulla-lulla.

When Caspar dreamed
He heard a prison
And felt a demon
In David's city;
Then saw three kings upon a byway
Far from the highway
Back to luxury.

Lulla, lulla, lulla-lulla.

When Herod dreamed
He felt a poison
And heard an orison
Deep in his palace;
Then saw himself eunuched in exile
Before a starry veil
Draped on a chalice.

Lulla, lulla, lulla-lulla.

When Jesus dreamed
He heard a choir
And felt the ardour
Of the Holy Spirit's Grace;
And then He saw the golden children,
Feted pilgrims
In His Father's warm embrace.

Lulla, lulla, lulla-lulla.
Lulla, lulla, lulla-lulla.

ii. Departure

Sadly set for Egypt, Mary says goodbye,
Knowing she must travel, scarcely knowing why;
Too tired and dusty to wipe a tear from her eye,
Doggedly determined, innocently shy.

Riding on a donkey through the barren wild,
Watchful and protective of her precious child;
Relieved but wondering what it will be like to be exiled
Infinitely patient, unfailingly mild.

No more homely shepherds, no more reverent kings,
Gone the wondrous stable and the birth star glittering;
And, taking each day as it comes, rooted or wandering,
Wedded to the mission of Gabriel's quickening.

iii. Massacre

Lost in the falling needles and the fading tinsel,
Buried in coloured paper and in turkey bones,
Not even shadows in our family rows and revels,
The Holy Innocents languish unmourned, unknown.

The earliest martyrs of our Church unconsecrated,
Killed between a pair of kings, too young to know,
The first Saints of the yet unwritten Second Covenant,
Of a line of victims reaping what they do not sow.

Now we have re-discovered Rubens graphic horror,
Remember the screaming sacrifice, the ruined mothers;
And in the name of He for whom they were slaughtered,
Suffer your children come to you; and all the others.

HONOUR ALL

Failing lights and dropping needles
Hardly fit to greet the kings,
Turkey soup and crusty Stilton,
Tired cards on sagging strings:
Christmas time that came too early
Ends in weary, bloated gloom,
Carols sung in late November
Fade as old routines resume.

Yet, as we watch with foreboding
As his presents are unpacked,
Jaded with our more than plenty
We should recall the things he lacked:
And as we resent the normal
We should walk his exiled way,
Grateful for the things we value,
Thankful for the quiet day.

May our purple, Advent season
Last until the holy night
When we sing our songs of greeting
Full of vigour and delight,
And may our extended season
Honour all that came to pass
From the Maid's Annunciation
To the Mother's Candlemas.

BRING YOUR CANDLES

Bring your candles for a blessing
Spreading light in home and heart;
Comfort in the nights of Winter,
With the glow that they impart:
Tranquil hours of contemplation,
Prayers to comfort, prayers to heal;
Giving warmth to friends and family
As we share a homely meal.

Light your candles happy Gentiles,
That same light which Simeon saw;
Warmth to melt the frost of duty,
Love to overwhelm the Law:
Light a candle for the mother
Whose light comforted Our Lord;
Light of holiness and beauty
In His Sacrament and Word.

SIMEON'S DEATH

Out of the dark, the old man came,
Half hidden by the swirling smoke,
Then ghostly, etched in flaring flame,
He raised his claw-like hand and spoke.

In faltering phrases, near to death,
He said his dream had been fulfilled,
And, as if with his final breath
He said his hope had been fulfilled.

His hand reached out to take the boy;
She had no option but to yield;
And, far from filling her with joy
She dreaded what his words revealed.

The ritual carried out in haste,
Shocked and depressed, they hurried home,
A sword had pierced her gentle breast,
Thrust by Jerusalem or Rome?

She heard the old man died that night,
Exalted by her child's face;
She wished that she had seen the light
That lit him to his resting place.

SOLIDARITY

How did that petal brave the storm
To lie upon the snow like blood,
How did that eerie shadow form
A cross from random slats of wood?
How was it that the straw so sweet
Pricked sharp against a new child's skin?
How was it that the hostile street
Was proxy for the festive inn?

Why did the God of love who made
The world subject himself to earth?
And, if he must, a cavalcade
Should have announced his noble birth:
And why should ignominious death
Inflicted in return for grace
Have interposed between his breath
And his farewell to time and space?

Blood is the fuel which prompts the will,
Sluggish or fired as we are flawed,
By which we choose for good and ill
Craving the solace of our Lord;
And God, who made 'his' creatures good
That they might love 'him' true and free
Gave his sweet self in flesh and blood
In human solidarity.

THE APPLE WOOD OF CALVARY

The apple wood of Calvary
In sweet, sad smoke obscures the star,
Then upward drifts as frankincense
To meet the angels from afar:
Eve's virgin child awaits her child
While Joseph makes the manger good;
The tree, the carpenter, the Cross,
He chose to work in humble wood.

The bloody marble, rigid, cold,
Surveys the edict's cruel sneer
As Herod, flushed from banqueting,
Is surfeited with wine and fear:
The cry of innocents resounds
As Pilate mounts the judgment seat,
His hands within the marble bowl
Twist in the baptism of defeat.

But, then, the star above the cave
Marking the place where Jesus lay,
Obscured by clouds of heaven's rage
Upon that dark, redeeming day,
Serenely rose the following night
To see the tomb's disgorging grace,
The manger's promise ratified,
God's embassy in endless space.

PAGEANT

Distance from hardship leaves us uncomprehending
Less understanding than the truly poor;
Partly the distance between two points expanding,
Further and further from what went before
But partly through distancing from the real,
Preferring the abdication of the sentimental
To the degradation with which we ought to deal.
The poor still cry in broadcast tribulation
While we take refuge in religious art;
We know the skeleton of our divine salvation
But think it can survive without a heart.
What started as wild farce becomes a pageant
With gaudy shepherds facing splendid kings;
No room for ragged plebs and crooked agents
In the aesthetic way of showing things.
We stare through the eye of a needle at the scene
But do not know how hard it is to care;
Intent on understanding what has been
Instead of understanding what is here.
The way to narrow distance is to pray,
To leave room for the Spirit in our hearts,
To greet the unexpected every day
And learn acceptance as each day departs

IF I COULD WISH

If I could wish upon a star
It would not be for chocolate, or a racing car,
Or an electric guitar,
But for a peep
At Jesus fast asleep.

If I could travel near and far
It would not be to Xanadu or Shangri-la,
Or the Istanbul Bazaar,
But to stay
By the Christ child in the hay.

If I could hear the sweetest sound
It would not be *Beim Schlafengehen*, or the nightingale
Or *A Winter's Tale*,
But the baby's cry
Stilled by Mary's lullaby.

THEN AND NOW

The holy child so beautiful
Infused the darkness with a glow
That made the weary stable bright
But that was, oh, so long ago!

They say that angels filled the sky
Bringing good news to all mankind,
And then they sang a joyful song:
But we are oppressed and undermined.

His mother might have thought the gifts
Irreverent fruits of tyranny;
But nothing is too mean for them
To take from struggling folk like me.

And yet when Christmas Eve arrives
Our chronic troubles disappear:
The beauty glows in every heart
And lifts us for another year.

THEY BROUGHT JESUS!

They took us from our villages,
Our homes of creeper grass,
And stowed us, worse than animals,
A sick and dying mass;
They drove us into slavery
With the shackle and the lash,
No cruelty too terrible
To get their sugar cash:

But they were a miracle:
With their wickedness and greed
They brought Jesus.

They said that he was one of them
So they were 'specially blessed
But we knew he was one of us,
Black, harassed and oppressed:
The whites, like Romans, lived in style
His stable was a shack,
He died an innocent, like we died,
But, glory, he came back!

And he is a miracle:
From Calvary and the tomb
Arose Jesus!

GOOD CHEER!

Light the candles,
Dress the tree,
Put the crib upon the mantel.
Buy warm gifts,
Make provision,
Crown the baubles with an angel:

*For Jesus is coming with light
On a Winter's night.*

Merry face,
Arms embrace,
Love those whom you do not like.
Feed the lonely
At your table,
Break the tension with a joke:

For Jesus is the Word
Told to shepherds.

Enjoy gifts,
Raise a glass,
Everything for all who come:
Make some time,
Make some space,
Make your house into a home:

For Jesus is visited by kings
With exotic offerings.

Bring new hope,
Take new strength,
Plan to be a little better:
One more prayer,
One more smile,
One more offering for the stranger:

For Christ is with us all the year,
Good cheer.

THE ROSE

See the rose in Summer glory,
Bloom of the Creator's plan;
Symbol of the joy of Mary
When she carried God made man:
Hers the beauty grief could never
Tarnish as she faced the tomb,
Magnified in Christ forever
In the transformed upper room.

God whose love in incarnation
Broke the bonds of time and space
Through his Son for our salvation,
Comforter in our disgrace:
From his birth to crucifixion,
From the Cross to hell on earth,
Jesus suffers our infliction,
Source and witness of new birth.

Spirit of Christ's consummation,
Source of life when all seemed lost,
In the words of consecration
And the fire of Pentecost:
Help us honour all creation,
Live the Kingdom hour by hour;
Filled with hope and expectation
Of the Triune love and power.

MISTELTOE AND HOLLY

My berries soft and white
Of timeless love
Embracing an old oak
In floating mist:
Kissing and kissed.

My berries bright and red
Of timeless love
Embracing all mankind
In pain and death
The Spirit's breath.

But where I am so gentle
You bear a prickle.

Your vaunted timeless love
Will not sustain
Without pain.

I gave my blood in love
For evermore,
For the unlovely and the poor:
Faces not dressed in mist
Shall still be kissed.

PETALS

A white petal lying in the straw,
A mother and her infant O so pure;
A tableau so quiet and so poor,
And yet it changed the world forevermore.

A pink petal floating on the lake,
Of fish and of souls a mighty take;
They could not believe it on the shore:
And yet it changed the world forevermore.

A red petal nailed upon a tree
The most precious blood in history
Poured out, negating what had gone before:
And so it changed the world forevermore.

A golden petal floating in the wind
Between the earth and sky for all mankind,
A mystery to worship and explore:
Because it changed the world forevermore.

VIRGIN OF THE RAJ

Virgin of the Raj
Geisha full of Grace
Bearer of Our Lord
For all God's human race:
Mother of the sick
Sister of the poor
Sheds a lonely tear
Outside the stable door.

Exile in the dust
Wanderer in the heat
Home at Calvary
To see His last defeat:
Servant of the dead,
Waitress at the board
In the upper room
Heard of the risen Lord.

ON BEAUTY

i.

Where beauty subtly warms the aching heart,
Seeming more pliant, mere prettiness hurts;
Thus, snow which hides the blemishes of earth
Wraps cruel fingers round a doubtful birth.

And, come the ugly thaw, bedraggled mess
Asserts itself, though something is amiss;
A shard of beauty lights the drizzling day
Transmitted from the manger where he lay.

iii.

The smooth, heroic elegance of rhyme
Unchecked by assonance betrays the theme;
Beauty is in the jaggedness of things,
Not in the smooth abstractedness of dreams.

The danger of Demosthenes is to speak
Where substance is subjected to technique;
Beauty is found less in the poetry
Than in Luke's story of Nativity.

ii.

Dull and worn out, sky, clothes and wood,
Insipid shabbiness from swaddling to shroud;
But then, Renaissance paint depicting light
Excludes the dull and champions the bright.

The grey of lowering skies and smoking lamp,
Fabric uncertain in its dye; and limp
Give way to shepherds bright in pink and green,
And Mary, blue as sapphire, Fairy Queen.

While hidden light heroic birth
The essence of its heroism is dearth;
In art technical facility must protect
Beauty from the snare of mere effect.

CHRISTMAS TOWN

Jesus calls the reindeer in,
Wise men huddle on a sleigh,
Joseph drinking at the inn,
Robins nesting in the hay:
Snow men line the empty street
Where the star is shining down,
Santa and the shepherds meet,
In the square of Christmas town.

Herod at his market stall
Selling gold and silver crowns,
"Jingle Bells", the angels call,
Filling sacks in dressing gowns,
Chestnuts roasting on the fire
In the stable snug and warm,
Joseph practising the lyre,
Jesus in his mother's arms.

Santa brings a load of straw,
Jesus Christ pretends to sleep,
Presents on the stable floor,
Will he dare to take a peep?
All the elves begin to sing,
Santa reverently kneels down,
Everyone is worshipping
Christ the King of Christmas Town.

MARY'S CHILD

i. EVE

When Eve turned her face for the last time
To look back at the 'tree of sin',
God thought she had never looked so beautiful,
Even though skins defaced her naked skin.

"Love out of adversity and loss
Is better than the heavenly bland:
They will love me and each other heroically,
Not mindlessly obeying my command.

"A father cannot help naive love;
But I knew that it could not last:
The garden was always too good to be true
Lacking a bright future from a dark past.

ii. THE SPIRIT'S FIRE

The spring and poise of young flesh
Tenses in sudden radiance,
Fixed like a marble sculpture,
Arrested in a girl's dance.

Her ears swelling with heartbeat,
She hears the voice within her;
How can Zion's Messiah
Be carried by a sinner?

The voice gently caresses
And fills her with desire;
She opens all her senses
And feels the Spirit's fire.

iii. PRESENTS

A walk into the barren hills
Away from harsh tongues whispering;
News of two cousins soon to come;
The herald and the people's king.

A Nazarite and Nazarene,
Remembering how the message came,
—She puts her hands below her breasts—
The outward light, the inward flame.

Her cousin, glowing with new life,
Repeats the words the angel said;
Then Mary sings old Hannah's song,
The poor raised up, the hungry fed.

Bound in God's hope they know their joy
Beyond the confines of their day,
Their bodies' presents to the world,
Their place in sacred history.

iv. BABY CLOTHES

Fine silk for a saviour,
The fabric of kings,
Bright and soft as butter
As it falls and clings.

Yes, linen is better!
It fits nice and tight
Around a new master
On a Winter's night.

Wool is well enough,
So soft and springy
The very stuff
For a new baby.

Then cotton bindings
Will have to do;
Like funeral windings:
And good day to you!

v. COLD

Snow like a lacen mantle drapes itself
Upon the shoulders of the ancient town;
Lending a transient beauty to the squalid,
Whitening black as it comes down.

But they who feel its bite know the illusion,
The doubtful elegance for a celebration;
The stable door wedged tight against the chill,
Against the cruel beauty of creation.

The swaddled infant laid within the manger,
His mother huddles in her temperate stuff;
They have no money to provide for Winter
When all their clothing would not be enough.

A cruel gust knifes through the flimsy slats;
The baby, cold and frightened, starts to cry;
His mother gives him all the warmth she has,
A breast, a kiss, her cloak, a lullaby.

vi. GIFTS

You might say all gold is the same,
Calibrated by volume and quality;
But I know its nerves, blood and veins,
Its mood swings and subtlety:
Not that bar; there was blood in the mine.
The monarch that I have in mind
Would only want to see it shine
And never trade nor melt nor grind.

Frankincense is more subtle still
As it varies according to tree,
At what height and what slope of the hill:
The priest designated to burn
This offering is one of a kind,
And so we must carefully discern
A fragrance for his cast of mind.

Myrrh is often dismissed as a waste
But no corpse will be rarer than this
Metamorphosing earthly distaste
Into untrammelled heavenly bliss:
For whom? We are sure of the birth
Of a child - all our tables agree -
Who will come down from heaven to earth
And set all of humanity free.

vii. WIZARDS

Like a magnet in the sky
The star conducts a desperate race:
Climb to pine
Plunge to palm,
Nestling farm,
Barren space.

Like a savage lunatic,
Herod simpers, snarls and slides:
"Find the child,
Bring me word.
Double dealing?
How absurd!"

Like a fever on the ground
The people shout and grasp and curse:
Camels haunched,
Money thrown,
Mistrust sewn
Hard to reverse.

Like a weight endured for years
Cargo slaps the dusty stone:
Gold and Myrrh
And Frankincense,
Star intense,
Then disappears.

Like a life complete at last,
Wizards' final spells are cast:
Worshipping
The infant king
Future blossom
Rooted past.

viii. WHERE?

Where is the sword to pierce my heart?
I only hear my baby cry
And what he needs I can supply:
Where is the sword?

Where is the grief that summons tears?
The old man smiles his prophesy
Touching my boy, looking at me:
Where is the suffering?

I know it, like the dead of night.
All that I pray for is a stay,
No hope of sorrow going away;
We only lack the year and day.
I know.

ix. MARY'S ENGLAND

Mary's infant carried high
Over the shingle band
To mellow England;
Through the mist
Jesus Christ
Borne on his muddy way
Through mossy England.

Safe from Herod's murderous bands,
Safe from scarred and cruel hands,
In the dappled, grassy lands
Of melancholy England.

Ah! But woe was the day
Through the thunder and spray
When they went on their way
From lovely England:
For they raised him on high
On a cross there to die
But his last, saving cry
Reached Mary's England.

VOLUME III

HOME FROM THE CROWDS

2014

PREFACE TO VOLUME III

Anyone assembling a third collection of Christmas poems from a Christian standpoint cannot avoid—indeed, would not wish to avoid—the implications of the incarnation and, more specifically, the projection of the events in Bethlehem towards Calvary. The shepherds and kings and the other witnesses of the sacred birth still have their rightful and joyous place but, sooner or later, the unfolding of the full purpose of God in Christ must be confronted. Nor can such an author long ignore what the birth of Jesus tells him about himself and his purpose in creation and his hope of salvation.

This collection, therefore, cannot avoid taking on something of a sombre tone but I hope readers will not think less well of it for that. No biography of a great person—and Jesus is the greatest person who has ever lived—could be content with material simply covering the life of the child; we all want to know how the prodigy turns out, particularly if our lives depend upon it.

Kevin Carey
Hurstpierpoint, West Sussex
Pentecost 2014

DECEMBER

i.

Dense, drizzle-laden mist rolls off the Downs
Closing the day early;
A pot of lapsang souchong's smoky tang
To warm and comfort through
The twilight hour of prayers to the first candle:

ii.

For all the year that's turned, half friends half lost
Already and the layered accretions of routine,
The gentle beauties of rare moments lacquered
Deepening the patina of what might have been.

Remembering this hour a year ago,
Slight resolutions and the books unread,
Failure to stir one day after horror,
The minor triumphs of the things unsaid.

A golden flame surmounts the purple column,
Atop the suffering may beauty shine
With the bright promise of your sacred mission
To alloy the human with the divine.

iii.

The wind across the sheep-strewn chalk blows almost
As sharp as frost
As velvet closes out the gathering gloom
Hugging the warmth
Against the probing draught that crooked candle flames
And lop-sided wax.

iv.

"Repent! Repent!
It's not rapacity that I resent
But pride
Which is too prominent for you to hide
Even when it is buried, deep inside."

Repent, repent.
The last time, not unnaturally, was Lent.
Reflections on the year
In cards and letters emphasise the fear
Of what we owe ourselves becoming clear.

"Repent! Repent!"
The fiery Baptist's torso, thin and bent
Swaying from side to side
Pours dirty water over gleaming pride,
With words so sharp they cannot be denied.

Aflame! Aflame!
Two hopes that things will never be the same:
The Baptist cries,
His message no surprise,
Self-knowledge bringing tears to our eyes!

V.

A break in the weather, powder, coral pink
On a sapphire cloth
Follows the winter sun over the rim
Of the upturned horizon:
Scarcely a Nocturne played
And the colours fade:

vi.

Home from the crowds,
This day of gifts,
The rose aglow
The purple lifts:
The open heart,
Though lacking taste,
Desires to please
In listed haste.

A time to ponder
Time ahead,
Advent purple
And Christmas red:
This rose fine tuned
In cheerful voice,
Quietly intones,
Rejoice, rejoice.

vii.

As if in wait for stars, the velvet sky
Falls silently
Towards the stealthily soundless whitening ground;
The flame's four points of light,
Have been completed;
The purple last, of Mary's humble crown
Heeding the Word:

viii.

Mother of Jesus, gentle and strong,
How should we praise your courage and loss?
How rank your fear when Gabriel came,
How feel your pain at the foot of the cross?

Who can resent the hymns in your praise,
The beauty of woman, the Lord at your breast?
Who can resist a prayer in your name,
For courage and comfort, for healing and rest?

Ave Maria.
Salve regina!
Alma redemptoris mater!
Stabat mater!
Ave Maria.

ix.

As Bach dies in the gothic vault of King's
The first flake falls;
The candle, white as snow where all lines cross
Flickers, then thrives;
Children are loud on their way to the crib
—Angels and shepherds—
While the old walk slowly to a memory
That is renewed
And lives:

X.

At Christmas time fresh carols bring
To celebrate our new-born king:
Old rhymes and tunes we gladly hail
But over-usage makes them stale;
Staples baked into novel fare
Make us more lively and aware.
Our age wants something new to say
And we need different words to pray.
Frenetic, urban lives require
Recalibration of desire,
Nostalgia for a bygone age
Obscures our message. Turn the page
To bring new songs of hope and cheer
Refocusing to make it clear
That what we celebrate is more
Than emptying the superstore:
Earth has its king, now celebrate
With tribute, simple, short and straight.
So, sweep the cakes and ale away
For Green & Black and chardonnay.

ANNUNCIATION

Mary at prayer before the rising sun
Drowned in a blaze of light
Stutters and shudders in mid Antiphon
Rooted from taking flight:

O holy maiden, only choice of God
Whose blood, fused with the Spirit, was His blood.

Mary entranced by troubling messages
Clutches herself in fright
Wondering what the turmoil presages
How can she make things right?

O holy maiden, Mother of the Lord
Through whom the Flesh was answer to the Word.

Mary at prayer after the setting sun
Offers herself totally
Whatever trouble now God's will be done
Blessed eternally.

O holy maiden, dressed in Heaven's veil;
In graciousness, remember our travail.

THE BAPTIST'S CRY

The melancholy of unrealised hope
Crystallises in a wild man,
Saying what the heart has not quite said
Since time began.

The sore relentlessness of sacrifice
At last gives way to water and the Word;
Love is as yet unenshrined
But hope is heard.

The golden halo of the enriched
Encompasseth not the outcast:
Jesus we see as softening the harsh
Message of what will come last:

Cousins in warning and redemption,
Martyrs standing out against the barren strong:
A dirge more than a hymn
For a desperate throng.

Remember his solitude and prayer;
The times the angels were not there;
The grating prophet of discomfort,
Of the unthinkable prayer.

As he waxes I must wane
But now on Jordan's bank
Reality is far more pressing than the theory,
Or the exercise of rank:

All realisations are collective,
Built upon a single spark;
So little yet of formulation,
Humble we must address the stubborn dark.

JOHN HERALD

"We interrupt this programme to announce
The birth of, what our correspondent says,
Is a long awaited child; though far away
The wonders of satellite technology
Mean that we can go live to Bethlehem."
"The baby prophets promised has arrived,
Although the contrast could not be more stark
Between the dingy stable of his birth
And a quite remarkable new star outside.
The mother and baby are doing well.
Locals deny the landlord's explanation
That he had no room in his crowded inn
But say he was deliberately holding out
For higher prices during the census.
Insiders say the news will cause a stir
In courtly circles but a reliable source
In Jerusalem says there is no serious threat
To Herod's role as trusty of the Romans.

The sleepy town is suddenly awake;
And if I were not a down to earth man
I would say that the sound I hear is like
A heavenly choir (if I knew what it was!)
I am being approached by a rough looking mob
Of shepherds playing pipes, they must be drunk!
This is John Herald for the News at Ten."
"Well, that was very nice. But we must return
To much more serious matters. Now children
It's far too late already, time for bed
In order to give Santa a clear run.
A baby in a stable, fancy that!
Goodnight children! Sleep well! Goodnight, goodnight!"

THE HUSH

The hush before a baby's cry
Rolls restless scrolls of prophesy:
The quelling of the ancient storm
Makes seas grow calm and winds blow warm:
Yet God incarnate born to die
Alone amid hostility
Lies tightly swaddled in the straw
Far from the vision they foresaw.

A mitre and a kingly crown,
An altar and a golden throne
Encompassed in a feeding trough
Of nails coarse and timber rough:
A pipe but not a trumpet blown,
A wriggling lamb, all bleat and bone,
Imparts its feeble warmth but then
The new-born baby cries again.

The lord of all reduced to prize
His mother's breast and restless eyes,
All power decanted to retain
His solidarity with pain.
The vulnerable fool defies
The iron logic of the wise,
And echoes in his infant breath
The weakness of his pointless death.

INNS

Not two coins to make a jingle
As they crowd the festive inn;
Not a word to warm my spirits,
Just a blurred carousing din:
Here's a man, travel-worn and harassed
Seeking shelter for the night,
His wife, pale, pregnant and embarrassed
Cowering from the doorway's light.

Not two coins to make a jingle
As they crowd the Metro bar,
Singing with half-drunken voices
Of a baby and a star:
Here's a woman shouting "scrounger"
As she passes with a lurch,
Drops her Christmas hat and staggers
Up the steps and into church.

CHRISTMAS EVE

i.

So many angels fill the evening sky,
So many shepherds herding so few sheep
And more wise men than an academy,
But only one new baby, fast asleep!

Such treasured childhood memories are passed on
But are they more than sentimental show?
Only God knows what his own son has done
But it is more than human mind can know.

ii.

When the day is over
And the candles flicker
And the fire grows warmer
And the snow falls thicker,
She says:
"Think of your places reversed, my dear
You out there, the rough sleeper in here!"

iii.

When books are closed and grave thoughts fled,
The lights put out, the beckoning bed,
An image halts my wary tread:
A baby in a cattle shed.

He may be in a Trinity,
A brave trope of theology,
But what counts more is what I see,
God in a child of flesh like me.

I feel the prickling of the straw,
The roughness of the earthen floor,
Wind threading through the flimsy door,
But do not know how to be poor:
And wish I loved a little more.

Jesus, here is a little prayer,
As I approach the nightly stair,
Help me to care as I should care;
I think I might now you are here.

STARS

We the stars of ancient rites,
Lighting the Olympian heights,
With the Gods firmly entwined,
Have our sacred place resigned.

For a new-born star we see,
Free of all duplicity,
Shining for a God so pure,
All the others to obscure.

Not a God of war nor lust,
Whom all other gods mistrust;
Born kenotically weak
Whom the poor and lonely seek.

Mere ancient curiosities,
We reserve no dignities
But sparkle as a sacred sign
For the God who makes us shine.

BE STILL, BE STILL!

Be still, be still!
Our Lord is near at hand.
We are the servants of His royal will
And bow our heads to hear His quiet command.

Be still, be still!
Here comes the Prince of Peace
To rescue us from life's remorseless mill
And grant to captured souls their sure release.

Be still, be still!
Wake not the sleeping child,
For He must face the powers that curse and kill
So that all sinners may be reconciled.

ANOTHER MARY

Your azure veil and flowing gown
Suffused with God's eternal light
Conceal the ferment in the town,
The squalor of that fateful night:
Was it a star or smoking torch
That guttered in the stench and storm,
Was it devotion or debauch
Which filled the shepherds with alarm?

The angel Gabriel's embassy
And your inspired *Magnificat*
Speak of unflawed serenity,
Predestined by divine *fiat*:
But were your thoughts so wholly calm,
Confronted with the social shame,
And were you safe from hurt and harm
For what you did in Jesu's name?

That halo of serenity
Which marks you out as strong and meek
Conceals profound uncertainty
Which tyrants visit on the weak:
Had you heard rumours from the kings
That added grimness to your smile;
Did you recall the sufferings
Of Israel's children by the Nile?

Mary, for all the artist's art,
For all the beauty you inspire,
I love you for the young girl's heart,
The raw salvation of desire:
For in the guise of harassed grace
I see you daily in the street
With heavy load and tear stained face,
Unsteady shoulders and sore feet.

And I might never come to see
Your likeness in Our Saviour's face
If you were dressed like royalty,
Familiar but out of place:
But, as you are, I am not shy
To bring a gift to please your child,
For you, like Him in majesty,
Are love itself but slightly wild.

WHICH WAY DOES THE WIND BLOW?

Which way does the wind blow?
Over the snow
With an eerie Monet glow
And a donkey's shadow.

What say you of the skies?
A portent, I surmise;
And a happy surprise
Before sunrise.

What say you of a king?
Nought but a baby, angels sing
Sweet songs of welcoming.

GOD'S LOVE IN THE FLESH OF A BABY

Frost on angel wings
In the starry sky;
Joyful heaven sings
Of the victory:
Of God's love in the flesh
Of a baby.

Earthly powers frown
In their disarray;
What price now a crown
On this holy day:
Of God's love in the flesh
Of a baby?

Love wins over power
In their endless fight
If but for an hour
On this Christmas night:
Of God's love in the flesh
Of a baby.

THE BABY KIND

Angels above a sleeping town
Announce a king without a crown;
But only outcast shepherds hear
Of power that they need not fear.

And when they come to see their Lord
They tell his mother what they heard;
And she recalls her foretelling
Of justice that her son will bring.

And even though her words are dressed
In pomp unknown to the oppressed,
The message will not go away
No matter what the cynics say:

For what the town missed in the night
Was love embodied in the light
That shines in us for welcoming
A baby as our heavenly king.

RIGHT FROM THE START

Sharp blows the shepherd's pipe
Wild blows the wind,
Dark stands the cattle stall
Sleeping the king.

Bright shines the prophet's star,
Soft shines her face,
Warm breath the cattle as
Jesus awakes.

Cold lies the winter snow,
Warm beats her heart,
Blazing the Spirit's glow
Right from the start.

REAL BETHLEHEM

Now snow has gone
And the wet wind drives in from the sea;
Now stars are dim,
Cloud reflecting sodium ubiquity:
When soldiers guard
The Church of Your Nativity
And bombs explode
In nameless, inhumanity:
Then Bethlehem is our woe
Not seen in deep and peaceful snow.

Now sullen wind
And unremitting, probing rain,
Now warm unkind
Plays music in a restless strain;
When neon picks
The rags of beggars in the street
And tills not towers
Join battle for your last defeat:
Then Bethlehem is our home,
A town of empire worse than Rome.

Now Satan sweet
Tempts with a moderate appetite,
Now tiny feet
Are lethal in the red and white;
When we no longer
Learn from pain and suffering;
And feel much stronger
When our hold is weakening:
Then Bethlehem must be real,
A town of torment, torture, blood and steel.

LILY

A tender lily
Near translucent in the snow;
Near invisible
In the tugging wind blow.

How shall it stay
On such a cruel day,
Florid in May,
December in affray?

A tender lily
Translucent in the snow,
Heaven's pollen
In the wind blow:
It shall be
That of greatest delicacy
Shall withstand
The cruel hand
And flourish
In the barren land.

SWEET JESUS

Inspired by The Holy Well, sixteenth-century, anon.

Sweet Jesus said unto Mary
Pray give me leave to play
But fellows young and lusty said
We must avow Thee nay
For we in gentle homes were born
Thee in a manger lay:
Sweet little king
What suffering.

Sweet Jesus said unto Our God
I willingly will die
For humble man Ye made me be
My Godhead to empty:
Living as poor, not of the law,
Made more our victory:
Sweet little king
What suffering.

Now mother I am risen up
My father's Glory shown;
Richness hath come from poverty
More than ever man hath known;
And thou wilt play in heaven above
As it will be thine own:
Sweet little king;
What revelling.

STRANGE DREAMS

Strange dreams and strange voices
Strange omens in the sky:
Dark words and dark choices
From angels passing by:
Sleepless with dreadful premonitions
And sudden decisions.

Our life of relentless rhythms
Of family, work and festival
Is broken.
But God has spoken.

Bright dreams and bright voices
Bright the angel in the sky:
Kind words and kind voices
From the shepherds passing by:
God was my premonition:
And my decision.

EMMA AND JESUS

Emma in bed, half asleep,
Waiting for morning to come,
Cheekily taking a peep,
Warm in the comfort of home:
Hoping for snow in the night,
Listening for bells and a sleigh,
Muddled in drowsy delight,
Ready for her Christmas Day.

Jesus, new-born, in the straw
Only wants comfort and sleep,
King of the weak and the poor,
Vaguely aware of some sheep:
Angels have gone from the sky
Leaving it troubled and grey;
Then he awakes with a cry,
Greeting the first Christmas Day.

SNOW FALLS

Snow
Falls so
Slowly,
Softly,
First a blur
In the air
Then a denseness
Of light
And a carpet lies there.

A carpet
That hides
The squalid
And be-gentles
The soldier's tread;
A wondrous holiday
Of change
Before its unseamedness
is shed.

And though
There was no snow
Where he was born
I like to think
He knew
The special quality of light
And sound
On that special morning:
A hallowing dispensation
To the raw ground.

THE VISIT

Bright the candle
Sharp the spindle
Still the cradle,
Sparse the table.

Strangers errant
Orders trenchant
House in ferment
Hidden infant.

Gold effulgent
Incense pungent
Myrrh plangent
Threatening presents.

Light the candle
Turn the spindle
Rock the cradle
Lay the table.

JOURNEYS

Across the barren plain
From which hills look the same
Where camel tracks are rough
And sand shifts just enough
To bring disaster
I sleep in stolen shade
Then as the shadows fade
I see the comet's glow
Drawing me on to follow
Even faster.

One night without a word
Our disparate routes converged,
Our camels formed a string
Our separate wandering
Woven into a band:
And as we looked ahead
To check what we had read
At once the comet flared
Before it disappeared
At journey's end.

Dawn roseate and calm,
Promising winter warm,
We took our cargo down
And each item was shown
To be exquisite:
Gold for a kingly price,
Incense for sacrifice,
Myrrh for the tomb fresh hewn,
The comet had not shown,
Ending the visit.

COUNCILS

The spy said:
"There is a strange pattern in the movement of kings,
Connected, somehow, with heavenly happenings."

The mandarin said: "There is a strong prospect of a King of the Jews,
We think it best to keep this out of the news."

The Guard said: "We could easily handle any civil unrest;
But think pre-emptive violence would be best."

The Council said: "Force is required because the case is so urgent;
But it will not set a precedent."

The King said: "Stability is more important than blood;
Let all the infant boys die for the common good."

The NGO said: "We have tried to preserve the rights of the child;
But those who escaped death have been exiled."

INNOCENTS

Blood on the grimy snow,
Tears on a faded shawl,
Flesh for the status quo
Spat from a marble hall:
Mothers that did not know,
Martyrs that heard no call,
Names scratched in shadow
On a tottering wall.

Death, calibrated, slow,
Strikes in a lethal squall,
Hovels reduced to a glow
Mock those on whom they fall:
Murder the world came to know
Power could not forestall;
Exiled so long ago
He still dies for us all.

HOMECOMING

Half known but still unknown,
Frayed patience at false starts
The sages con their ancient charts,
Their prize the measurement and span
Of time and fortune known to man,
The tyrant and the throne.

Such unrelenting rules
For such a crucial rite
Fearing to question what the stars invite;
An extraordinary king,
Reckoning after reckoning:
Heroes or fools?

Home, dusty and shattered
Cracked chests and stoved-in casks,
Hoping to circumvent what duty asks
About that mysterious child too
Subtle for a measured view
Of whether it mattered.

THE SNOWMAN AND THE BABY

A snow man anchored in the snow
From which it came to be
Dies unremarked, silent and slow,
A transient history.

A baby bathed in radiant light
Of which it is the source
Dies violently in day made night
As love encounters force.

Yet we will always live in light
Building in love although
Our efforts will be cold and slight
Because we build in snow.

What we construct time will destroy
As transient works of earth
Rehearsing everlasting joy
Made solid by that birth.

HALF WAY

Half way between the darkness and new light,
Between numb winter and the thought of spring,
When joy and sorrow strive on Simeon's brow
It is of a fair maiden that we sing.

Between the wooden manger and the cross
The berry fractures and its poison flows,
Spattering its grief upon a maiden's cloak;
We light a candle to recall her woes.

Between His incarnation and the carnal,
She hovers in the fire, human bright;
Not probing in the dark of winter gloom
But blackening the cross with Easter light.

IF WE COULD CHANGE PLACES

If we could change places
And I had your power
You would be sleeping
In a warm, scented bower:
Not wrapped in poor swaddling
But pleasant in silk,
As white and as warming
As your mother's milk.

If we could change places
And I had your power,
We would be watching
From a tall, granite tower:
Not frozen in terror
But safe as the spring,
The Lord over Herod
And Israel's King.

If we could change places
And I had your power,
I would give it all back to you
With my small store:
For love is the power
To set the world free,
Not cold and conditional
But full endlessly.

LONG AGO, LONG AGO

Fingered by the searching cold,
Cutting wind on cruel snow,
Born not far from death was he
Long ago, long ago.

Threatened by King Herod's wrath,
Lashing out to find a foe,
Fled, not far from death was he
Long ago, long ago.

Strange the story that was told
Of the desert and the snow,
Poor, outcast and suffering
Long ago, long ago.

Were he born in luxury,
Servants passing to and fro,
Could he know my suffering
And how hunger lays me low?
He is mine for what he bore
Long ago, long ago.

O GATHER

O gather sweet flowers
For the young maiden there,
And weave them in garlands
To put in her hair:
And embrace the young man
So shy and sincere
For their imminent wedding.

O gather sweet straw
To give him soft rest,
And moss for a pillow
And milk from the breast
And wrap him in in sheepskin
That the shepherds have dressed
To greet his coming.

O gather sharp thorns
For the criminal's head
And make him a crown
For the king that he said
He was but in five hours
This king will be dead
Ready for entombing.

O gather bright stars
To embellish his throne
And that of the maiden
Who bore her sweet son:
And round them we gather
Our hearts all in one
Joyful at his rising.

TELL ME THE STORY

Tell me the story. I am cold
And need to know that He was too;
That he suffered the world's sufferings,
Even worse than me and you.

Tell of the shepherds in the night.
I need to feel their dreadful fright;
And know how angels brought the news
Of freedom from the world's abuse.

Tell of the gifts the wise men brought,
That all their riches came to nought;
But that their worship at his shrine
For all their rank but equalled mine.

Finish the story. I am weak,
Losing the strength to think or speak;
But he was killed by and for me,
Bitter the taste of mystery.

NATIVITY AND PASSION

Thy tiny feet are pierced with nails,
Thy halo has made way for thorn,
The lash, not the caress, prevails,
The angel choir descends to scorn.

Thy mother saw both joy and loss,
Thy stable was a tomb in wait,
Thy paltry manger made a Cross,
Thy Census scroll a plaque of state.

The Shepherds' lamb, thine own device,
The ass returned to seat a king,
The Magi gold a silver price,
Thy birth a final
Reckoning.

HOW?

How can we hear his wakening cry
Yet still not hear him in each child?
The victim smeared with the fault,
The outcast vilified as wild.

How can we watch the shepherds kneel
Yet patronise the humble deed?
The poor blamed for their poverty,
The rich admired for their greed.

How can we track the wise men's star
Yet chase each glittering fantasy?
The calm rejected for the shrill
And wisdom for celebrity.

And yet we will do all these things,
Bowing before pride's tinsel throne;
Yet he who lies before us now
Has come to claim us for his own.

SPARKS

Glittering lights
All bright and cheery
On winter nights:
Joy on parade,
All neat and tidy,
Encouraging trade.

Candles are quaint
But somewhat risky,
Requiring restraint:
There's something
un-English
About being holy,
It's best to extinguish.

Sparks are a nightmare,
Random and oblivious,
Falling just anywhere:
Love and fire,
Out of control,
Far worse than desire.

ALL THE WORLD'S MUSIC

Sing all the world's music,
Pray all the world's prayers,
Bring all the world's beauty
To picture our lord:
A birth in the silence
A night full of fear,
Then light, words and music
Only shepherds could hear.

The word of the angel,
Good news for the earth,
Not quite comprehending
The wonderful birth:
Their music the angels,
A baby their prayers,
A life changing moment,
Ours as well as theirs.

EXCUSE OUR FOLLY

Gentle Jesus,
Excuse our folly
Wrapping your birth in tinsel glare,
Decking your crib with sprigs of holly,
Filling your stable with reindeer.

It should be enough
To keep the plain,
Perhaps a halo, nothing more;
To live in mystery, not to explain,
To celebrate as if we were poor.

Send the Holy Spirit
To find us a quiet place
For a little prayer,
And in a lowly place,
To find you there.

THE KISS

The kiss of a snow-flake
Softens the steely gloom;
A spark before daybreak
Shoots from a blazing womb:
A cry from the timeless
Breaks into common time;
A star's mystic brightness
Announces the sublime.

Shepherds, shepherds tell me
What did you see?
A vision in the sky
Of angels passing by
A voice fulfilling
Every prophesy.

A baby lies sleeping
With shepherds all around;
His mother is weeping
In joy, without a sound;
The star is so bright
It sweeps the gloom away,
As this sacred night
Turns into hopeful day:

The star promises kings
With precious offerings
Of gold and incense rare
And the foreboding of myrrh,
The glory and the sadness
That it brings:

But set your eyes upon a higher throne
Of glory that until now was unknown,
On beauty that no earthly power can clone
And flawless love that earth can never own,
The promise that we will not be alone.

ANOTHER WAY

No angel can console
Be it so proud and bright
Nor can the star enlighten
The darkness of this night:
For what was born in wonder
Is dead upon the tree,
The innocence of Ephrath
Engulfed at Calvary.

The candles for the virgin
All sputter in the rain
The laughter of the fishermen
Turns into doubt, then pain:
When back at the beginning,
The message was so clear,
But in the carnage of the Cross
It seems to disappear.

No angel can reveal
Be it so meek and coy
The Risen Christ's return
And our eternal joy:
Yet could there still have been
A way to spare His breath
In Ephrath's dark manger
And His even darker death?

BODY AND SPIRIT

Hope's distant light
Makes misdeeds sore;
Pride's slick fix lit
By the day longed-for.

Hope in a child
Surfaces shame;
Our failings lit
By a candle flame.

The Easter wonder
Is far too bright;
Our misdeeds fade
In ethereal light.

The empty tomb
Makes the spirit wild;
But the body yearns
For the little child.

HOPE

Treading the broken way with care,
Scanning for a smoking flare,
Even the checkpoint seems welcoming,
Though hardly fitting for a king!

For winter is more sour than sharp
As canker creeps and door frames warp;
A chronic mildew in the manger,
Laid out of danger into danger:

>And then the sky explodes in blaze
>Of light to frighten and amaze;
>And rumours of good news confound
>Those who would keep their feet upon the ground.

>>Then shepherds with the gift of speech
>>Spout like the prophets to a screech,
>>As sneers of ridicule deny
>>The message that the angels,
>>Yes, the angels
>>Poured down from the sky!

And in the game of holy chess,
The crib in all its wholesomeness,
I try to sink to where He lay,
On prickling and sodden hay:

>For if there is no thought to grieve,
>I hardly think I could believe,
>Humility being all I crave,
>And hope beyond my unkept grave.

DREAM

Sleep my love against
The old wind blowing out,
Dream of the new wind sent
To blow the proud about.

Sleep my love until
You hunger for my breast;
Dream of a life of love
To comfort the oppressed.

Sleep my love unless
You know more than I know;
Dream of the heaven sent
To us below.

SPRING DREAM

Each flake so perfect
Seen alone
Then settled on one
Of myriad thrones
Carpeting earth's thorns and
stones
With a beauteous mantle.

A moment to sing
Of the king
But blood is dripping
Upon the sheen;
Beauty grown cruel and biting
cold;
And the child dreams of spring.

PROMISES

Upon the brow of a barren ridge
A donkey etched against the sky,
Its burden shot through with labour pain,
Its guide cajoling passers-by.

"No room," they say. "Blame Caesar's tax.
But there's a place where the cattle stay."
And meek as peasants must learn to be,
They settle down upon the hay.

A smoking lantern for a nurse,
Rough bands of cloth to adorn a king,
A shepherd's pipe to announce the birth,
A doleful fanfare for suffering.

Upon the brow of a barren ridge,
Three crosses etched against the sky,
Their burdens ravaged with dying pain
Insulted by the passers-by.

One figure bows his grieving head,
Another, crowned, says: "Come, be with me."
And what God promised in Bethlehem
Was put in doubt at Calvary.

And yet my story has one more twist,
That Christ who died rose from the dead;
And sent the Spirit to take his place;
Thus doing everything he said.

HALO

The golden halo round his head
And satin bright as flowers,
Are marks of power inherited
To signify his heavenly powers.

But pretty as the scene might be,
Depicting pomp and fuss,
He set aside his dignity
And came here as one of us.

'TIS CHRISTMAS!

Hear the church bells ring out!
Hear the organ shout!
'Tis Christmas!
Satan is shut out!

Hear the angels sing!
Children caroling!
'Tis Christmas!
Hail the infant king!

Hear the baby cry.
Hear a lullaby.
'Tis Christmas.
God on earth to die.

RULER OF ALL

I heard of his birth
Long after the drama,
Hope for the whole earth
In a baby so poor.
I heard the old story,
Embellished and reverenced,
When the shepherds lacked money
To settle their score.

I made my escape
To the unfriendly city
Where oppression and rape
Were my lot as a whore:
But I heard what he said
On the steps of the Temple
And remembered his bed
In the Bethlehem straw.

Just for old time's sake
I watched his last moments
And felt the earth quake
As he made his last call:
But the news of his rising
From the tomb of the dead
Was hardly surprising
For the ruler of all.

HEAVEN KNOWS WHY

Heaven knows why
Such a sweet child
Should make me cry.

Now fast asleep,
The words I heard
Still make me weep.

Saving is such
A trial for Him
Who loves so much.

DUNSTAPLE'S BENT HAND

The damp wind melancholy moans
Informing Dunstaple's bent hand.
How should we be so full of woe
In such a green and pleasant land?
Why, eastwards the impassive sun
Sees flocks diminish in the sand,
Where one more precious than the rest
Was slaughtered at our harsh command.
O sweet lamb, born in poverty
Beyond what we can understand,
How should we celebrate your birth,
Escaping from the brash and bland,
How worthily receive your gifts
Cascading from your pierced hand?

O lamb, whose cry in Bethlehem
Promised to mend so great a tear;
O lamb, who died yet comforts me,
Accept this sad and wild prayer
That in between the two extremes
Of celebration and despair
I will attain a middle way,
Knowing that I will find you there.

METAMORPHOSES

Slipped from a cloud's womb I am, falling
As the pilot raindrop of a sharp shower.
Growing colder and whitening in harder softness,
As I slow down, as I drift lower.

A metamorphosis, I am told, although
I never hope to see such summer beauty
As the butterfly emerging from a chrysalis,
To live a brief and radiant life; then die.

I touch another life of beauty when I reach
The earth, the first flake to set upon
A tavern's stable yard in Bethlehem;
A thaw, and I am soon gone.

The chrysalis of a persecuted man, broken
Upon a cross becomes the Easter butterfly,
So radiant, with its white and gold and veins
Of blood; and it will never die.

SONNETS ASKANCE

i.

"Ne had the apple taken ... taken been,
Ne had ... Our Lady abeen heavene queen."
The retrospective pieces fit too neatly
Too blatant a re-writing of history
As if the God/Creator simply craved
A way to damn us so we could be saved
By his own agent, something of a son,
Through whose death at our hands, our freedom won.
Better to think the apple made us free
To love him and each other fitfully,
Better than angels fixed in their degree,
Forging our brittle solidarity:
Ne'er had the apple been neither would we
Have been more than the blossom on the tree.

ii.

Exhausted by the ordeal of the knife
And fire but waxing faster than his son
Abraham sees his revivified wife
And wonders what advantage he has won.
Another angel: trouble on the ground
As if there were not enough overhead:
He hears the stage whisper of heavenly sound,
Trying to understand what is being said:
As many as the stars that he can see,
As many as the grains there are of sand,
Are promised but his fragile progeny
Is traumatised beyond what they can stand:
Still, what the Lord has promised must occur;
God is an act not a philosopher.

iii.

A promise flickers in the dying flame,
Flaring before the room is left in dark,
God will not grant another lightning spark,
Content to leave his people to their shame
- Death, when it comes, is a catastrophe
Not lessened by the hopes of prophesy -
But being left is unlike leaving off:
The impulse is to promise and explain,
To lend collective meaning to the pain,
Vaguely adducing hope when times are tough:
Maidens will conceive and bear in due course
And one is set apart, a special force:
The people will rejoice if it prevails,
But be no wiser if the gambit fails.

iv.

Turned from the rising sun she kneels to pray,
God before nature at the break of day,
Bent on retaining the residual gloom
But restlessness assaults her Psalmody
As light behind closed eyes, brighter than day,
Transports her from her prayers and the room
Into a heavenly realm where a dark voice
Offers what seems to be a holy choice
Although, suspicious of her carnal need,
She hesitates before timid assent,
Knowing that both her families will be bent
On ostracising her for the misdeed:
But, blazing in her womb, the Spirit sears
Her with belief and all doubt disappears.

v.

He could not think what made him say "The lamb
Of God" when what he wanted to say was "The ram",
Religion being cruel to be kind,
Entwined with sin, the lot of humankind:
But he had heard his cousin's quiet voice
Cut through the self-aggrandisement of men,
Secure in ritual for power's sake,
Telling his wondering audience to rejoice
As if the world was free to start again,
With promises he knew that they would break
Jeshua and he were poles apart on sin
And he knew soon he would have to give in:
He scarcely felt the hand that bids him bless
Him in a gesture of futile redress.

vi.

The planetary weather, glittering, slow,
Subverts the human sense of time and space
Rendering the wildest hurricane effete,
Although the converse seems to be the case
- The human record of catastrophe
is nothing to a dying galaxy -
Each celebrated in the alien snow
And in a star exploding out of place,
Combining to produce a flawless sheet
Of frigid calm, misrepresenting grace
As if snow were on an aesthetic par,
Of equal beauty, to a glittering star:
But each needs each as both were made by him
Who knows them now, far from the cherubim.

vii.

Sing, angel voices in the winter storm
The news you bring of charity and calm
For we have sung our penitential Psalm
And crave good news to keep us bright and warm
Although we know the price was dark and cold,
A lowlier birth than any we have known
In turbulence, far from your heavenly throne,
Of squalor unpromised in things foretold,
Easy to subvert with haloed veneer
When children's fancies should be set aside
To celebrate only with modest cheer
Knowing that God as man was crucified:
Our Christmas will turn bitter in the spring
If we expect to crown this child as king.

viii.

Bad news always arrives sooner than good:
Soldiers despatched in haste always bode ill,
Not least when they ride out before the spring
When keeping warm and quiet is their aim;
But Herod's fear is worse than his bombast.
All life below his tottering rank is fair
Game if killing it will keep him there.
They reach their cowering objectives at last
And murderously seal their master's fame
With innocent blood that questions who is king.
Is Herod suffering a lust to kill
Or one whose motives are misunderstood?
Against the precept that he would present,
We rank the outcome higher than intent.

ix.

Blood in the gold that only he can see,
Standing like undressed liver on a slab,
No better met head on than like a crab,
A molten lump of jumbled cruelty.
Smoke from the frankincense meant to obscure
The craft of self-styled supplicants blows clear
To show the priestly tribute from the poor,
In exquisite attire, smooth yet austere.
Myrrh hovers at the edge of every crowd,
Not willing to be shunned as morbid fare,
Yet always presaging that final shroud
That splits its victim into earth and air:
Whatever they had brought would be the same,
The flaw His father wrought in heaven's frame.

X.

How clear the joyful bells across the snow
Made sweeter by the rarity of cold
As winters wet and windy overthrow
The paradigm of Christmastide of old
Call most of us in vain to Midnight Mass,
Content with glib and clichéd caroling,
Grown ignorant of how Christ will surpass
Our mundane hopes, of why we pray and sing,
Yet when the bells fall silent and the elves
Have smothered Jesus in a scarlet coat
Making our memories of Him so remote
That we think we are here to save ourselves
He will be born again to save us all
Even if we no longer hear his call.

xi.

The blackened organ staves of knotted chords
Assault the plangent dissonance of the choir
Producing music few minds can retain
Or voices render, dismembering words,
Substituting intellect for desire,
Roughening the places that were made too plain
With coats of nineteenth-century sentiment,
A brightly coloured pageant, in the snow,
Surbiton layered on Florence on Palestine,
As if the stable were a monument
To public virtue and the status quo
Domesticating Christ and the divine:
What carols shall we sing or pictures paint
Wrought with humility and self-restraint?

xii.

Long after cribs have given way to trees
With Father Christmas as our winter king,
And gadgets as our only deities
And presents as the joys of which we sing,
When Bethlehem's star is dimmed beyond our gaze,
Obscured by smoke and artificial light
And angels decorate but never praise
Upon fading nostalgia's special night,
A glib reversion to the pagan ways
Before they were transmuted into love,
When people were intent upon the ground
And not what might be sent down from above:
Though God will have to save us from the elves,
More, we will need to be saved from ourselves.

VOLUME IV

AS I WALKED

2015

PREFACE TO VOLUME IV

As contemporary Christmas carol music becomes ever more melancholy, reaching almost naturally for the minor key, it is not surprising that this fourth collection of Christmas poems, written to provide composers with new raw material, should somehow have tended in that direction without my knowing it, perhaps exemplified by the profusion of lullabies which never quite escape the melancholy.

While I was writing, I could never quite rid my mind of the persecution of Christians in the Middle East and this had the indirect effect of showing me just how little we treasure Christmas, much in the same way that we have come to take almost everything for granted that is beyond the wildest dreams of most of the inhabitants of God's earth now and in every previous age. Indeed, without wishing in any way to condone the current violence, at least one cause of iconoclasm is a "puritanical" reaction to excess and so, though indirectly, they are linked. Yet, conversely, it is a contemporary fault to conflate reverence with seriousness and I hope there is just enough humour to leaven the lump.

Kevin Carey

Hurstpierpoint, West Sussex
Octave of Easter 2015

A DEATH AND A BIRTH

Sonnet in memoriam Dave Coyle

For those who go with cold words to the grave,
Whose lives are ended with their earthly ends,
Thinking their only legacy is friends
And family picking for something to save;
And for those who determinedly face
Oblivion's prospect, both resigned and bleak,
Thinking a hint of godhead makes them weak
Rather than offering more mental space:
I like to think a Christmas card half-glanced,
The helpless baby 'posturing' as God
Touches a sense of something more than odd,
Potential, differently circumstanced:
Yet we are not the arbiters of grace,
All goodness will be held in Christ's embrace.

NIGHT STORIES

i.

See a princess rosy-cheeked and dressed in white,
 Dressed in white
In her castle tower shining marble bright,
 Marble bright
Fear the dragon breathing fireballs scaly red,
 Scaly red
And the wizard casting spells of doom and dread,
 Doom and dread.

Sing the song that carries all your future hopes,
 Future hopes
Love the world through microscopes and telescopes,
 And telescopes
Ponder all the wisdom of philosophy,
 Philosophy
Learn the lessons of the whole world's history,
 World's history.

Myth and wisdom fade before our new-born king,
 New-born king
Jesus Son of God, maker of everything,
 Of everything
Kneel beside the crib with shepherds and their sheep,
 And their sheep
Sing our song softly to help him fall asleep,
 Fall asleep,
 Fall asleep.

ii.

Keeping an inn is melancholy,
Dullness to dreams and then despair,
Wine deadens then revives the weight of care,
But I am expected to be jolly.

Always too much wine and not enough money,
Too much to do and never enough time,
I cannot make the awkward phrases rhyme,
And never say anything you would call funny.

I wasn't serious about the byre,
But next day when I looked they had all gone,
Leaving a strange impression hanging on
And me with inarticulate desire.

A strange old story always helps an inn,
Which explains why some sages sought us out,
Knowing more than us what it was about,
So fill your glasses and I will begin.

iii.

So fearful the sky,
So mighty the sound,
We covered our eyes
And fell to the ground:
The voice brought good news,
Or so its words said,
But we thought it untrue,
And feared we were dead.

So tiny the babe,
So radiant the star,
Which shone on his crib,
The door standing ajar:
We fell to our knees,
Still held in a trance,
And prayed for release
From this dread circumstance.

In a moment of bliss,
It all became plain,
We were heavenly blessed
With no need to explain:
But nothing lasts long,
Like the life of our sheep,
And we forgot the song
Which we learned in our sleep.

iv.

What is a wise man next to this child?
Books will fall short of what he will say:
We conned the figure but never the form
When we were far away, far away, far away.

Who rules the heavens, making such light,
Breaking the rules by which planets must play?
We posed the question but heard no reply,
When we were far away, far away, far away.

Why do our treasures now seem so small,
Laid at his feet, as his hands seem to pray?
We know the answer but never the form
Now we are far away, far away, far away.

V.

A song half way to heaven,
Star bright beyond all lights,
A prophesy half given,
Night far beyond all nights:
A child half dead from cold
Is king for evermore,
A world half mad with gold
Re-fashioned for the poor.

The song fulfils all hope
As brightness comes to earth,
The promise beyond scope,
Encompassed in a birth:
The grace of Christ Our Lord,
Earth's dignity made good,
Its tarnished state restored
By his own precious blood.

A man of no account,
With barely wit to lurch,
Makes his unsteady mount
Up to the midnight church:
Takes one last, gurgling swig,
Hides his flask behind a bush,
And kneels before the crib
In the reverential hush.

ADVENT PRAYER

As we await your coming Lord,
In quiet reflection may we pray
With penitence and humble heart
To make us worthy of the day.

Lord, we are not above the world,
Loving the fruits your bounty brings,
But seek some respite from good cheer
To fix our minds on higher things.

Our joy will bloom when you arrive,
The waiting will be worth the stay
Of revelry not in your name
Until you come on Christmas Day.

THAW

Come Jesus quickly. As the dark draws on
Our patience falters with the fading light,
Oppressed by plenty, glittered into gloom,
Bold artifice cannot withstand the night.

A grief like snow sweeps in across the plain,
Soft and diffuse yet cold in every flake,
Its thawing followed by the crack of ice,
Its treachery impossible to take.

Bring hay for tinsel, a manger for the sleigh,
Come quickly Lord, harbinger of the thaw,
Or else the cold will break my brittle heart,
Which longs to be with you forevermore.

ADVENT CALENDARS

Behind each tiny door
A chocolate awaits
The eager hands that tear
It from its glistening coat:
Where are the angels, where,
Who promise the divine,
In outline drawn and referenced
In a cryptic line?

Tomorrow is too late,
It must be ours today:
Bring everything we see
Unwrapped, without delay:
When church bells finally ring,
Our shallow ennui
Writes off the infant king
As ancient history.

ADVENT HYMN

1. Of God's unending, perfect love,
The child awaited, long foretold
By prophets in the blazing sands,
Prepares to bear the dark and cold:
First for his chosen people come,
His promise then outstretched to us,
That all might be embraced in in him:
A patre unigenitus.

2. Word before time of promised flesh,
A sketch in David and his sheep
Realised in Bethlehem at last,
The shepherd of the whole world's sheep:
Who came in quietness for peace
Beyond what our poor words can say,
None has nor will be great as he:
A solis ortus cardine.

3. Yet though he was of royal line,
The angel palaces eschewed,
Asking a maiden for her womb
As shelter for the Son of God:
"I am his servant," she replied,
"For what he wishes, I am fit."
In spite of scorn in human eyes:
Maria ventre concepit.

4. Shepherds and kings came in their turn,
As monarchs and the enslaved pray
To see the rose of Jesse's stem
Bring forth her child on Christmas day:
God's glory pent up in a star
Dispels the pall of man-made gloom,
Spreading its light both near and far:
Agnoscat omne saeculum.

5. O lux beata Trinitas,
As we make ready, may we clean
The stain of excess enterprise,
Clothing ourselves in humble sheen:
To you in heartfelt penitence
We wait, for him to show the way,
Knowing your child will save us all:
Gloria tibi Domine!

AGEING

Great losses for small gains
Are the accountancy of age,
A book of life once brimming,
Now a meagre, single page:
And all the smiles of decades
Pinched to futile, pointless rage.

Yet every year, defiant of time,
My rituals decree
An advent wreath, carols, the crib,
Gifts set beneath the tree,
To celebrate a timeless truth,
A promise kept for me.

CLOUD

All here facing our book
Of digital delight,
The networked stars all out
Upon this special night:
A tide of love and thanks
Compacted into texts,
Instant and full of grace
Beyond what aunt expects.

Dad's phone is obsolete;
Angels in 'selfie' rings,
Shun shepherds, as they should,
To photograph the kings:
The postings, thumbed on high,
The glittering cloud expands,
Vibrating constantly
With miniscule commands.

Real angels never cease
To read the pulsing mass
Of love and self regard
In clusters as they pass:
The Angel Gabriel says:
"The stable trend is slow.
It's time to tweak the cloud:
Make Jesus viral! Now!"

CHRISTMAS DAY IS COMING

Tell the tale of running deer:
Christmas time, Christmas time!
Spread the message of good cheer:
Christmas Day is coming.

Dress the tree and stack the shelves:
Christmas time, Christmas time!
Dream of Santa and his elves:
Christmas Day is coming.

See the new-born baby lie:
Christmas time, Christmas time!
Born for us, a mystery:
Christmas Day is coming.

Praise and generosity:
Christmas time, Christmas time!
Full of joy and yet holy,
Christmas Day is coming.

CALL CENTRE

A light shines where we least expect,
A song flows down the wire,
A heart grown cold in pleasure's grip
Bursts into cleansing fire:
The restless eye goes on the blink,
Grey steel breaks into red,
The history of faults wiped clean.
The tyrant screen is dead.

A baby in a manger lies,
Far from the pomp of Rome,
Soon to be made a refugee,
Far from his humble home:
His cruel death will save us all,
No matter how we fail,
Though callousness and knotted pride
His power will prevail.

A sudden light, a sudden child
Transforms the dark and cold,
An email from the refugee
That he will not be sold:
A church bell peals across the waste,
Too early yet to leave,
But I leave with a cheerful step,
For it is Christmas Eve.

THE CORE

Advent's waiting brushed aside,
Gone the long, repentant view,
Swallowed by the crimson tide,
Purple losing all its blue.

Lost the fast before the feast,
Sated long before the day,
Spending every year increased,
Scented candles in the hay.

Carols once sung at the door
Preen themselves as works of art;
Now consumed, whereas before
Praise flowed from an open heart.

Lord, help me separate the core
From sentimental fantasy,
That I may learn to love you more,
Discounting the periphery.

A CHRISTMAS EVE REFLECTION

Fast runs the race as the last evening falls,
Flash more than thought betrays the ritual's force,
Hurried affection grasped from glittering halls,
Fails to conceal the vulgar and the coarse.

Though faltering and short, better the prayer,
Like lips on stone, love makes rough places smooth,
Better the gesture of unhurried care,
The gloss of patience time will not remove.

Yet Jesus came to free those caught in briars,
Only he knowing how the seed fell there,
Better to leave him with their brash desires,
Better for us to fortify our prayer.

CHILDREN'S CHRISTMAS SONGS

i.

See the girl with her head bowed,
See the shining angel stand,
"Mary, I have come to greet you,
Sent to you by God's command."

"He would like himself made Jesus
As a baby here below;
Could you undertake this mission,
Jesus born for all to know?"

"I can feel the Spirit moving
Deep inside; I will obey,
Willingly accept God's promise,
Love the baby, come what may."

ii.

Clip-clop donkey,
Slip-slop donkey,
Trudging through the ice and snow,
Down the hill towards a tavern,
Welcoming with lantern glow.

'No room Joseph,
No room Mary,
There is no room here tonight;
All of you can share the stable,
Where I hope you'll be all right."

Little brother,
Baby Jesus,
Lying on a bed of straw,
Help us all to love each other,
Help us all to love you more.

iii.

The sheep were afraid of the trumpets,
As we were afraid of the light,
We heard a voice from the sky shouting
Good news; but it filled us with fright.

When all the drama was over
We went where a shining star led,
To see a babe laid in a manger,
Exactly as the angels said.

iv.

Lullaby sweet darling,
Sleep sound through the night,
Time enough to worry
With the morning light.

Our poor best we offer,
To lay you in a manger:
I would give my dowry
To keep you out of danger.

Lullaby sweet darling,
Song turns into tears,
Close your eyes, my darling
I can't hide my fears.

Lullaby, lullaby,
Lullaby, lullaby,
Sleep until the morning
Song turns into tears.

V.

Even the camels smiled for joy
At journey's end, at journey's end
As we first saw the little boy
At journey's end with Jesus.

We brought Gold, frankincense and myrrh
At journey's end, at journey's end
For our new king told by a star
At journey's end with Jesus.

We laid our presents at his feet
At journey's end, at journey's end
Thanked by his mother's smile so sweet
At journey's end with Jesus.

CEASE TO PINE

What a poor child to see
When there died two in three,
Ah me!

Why came he so poor
Who reigns for evermore?
Hurteth sore!

Lay he in the hay
That blesséd day
We kneel and pray!

King threatening a king,
Babes killed at his bidding,
Sadly we sing!

Mine all at rest,
Scarce from the breast,
How blest!

Cease I to pine,
Though divine,
This childe is mine!

AS I WALKED

I saw a lady dressed in blue
As I walked to-
wards Bethlehem,
Raising her head to see the view
Of Bethlehem, of Bethlehem.

I heard a new-born baby cry
As I walked by
In Bethlehem,
Beneath a wondrous, starry sky
In Bethlehem, in Bethlehem.

At midnight everything was still,
Climbing a hill
Near Bethlehem,
Then angels sang "good will, good will"
Near Bethlehem, near Bethlehem.

I had the sense of a new start,
Set to depart
From Bethlehem,
Of something stirring in my heart
From Bethlehem, from Bethlehem.

239

PAST ALL EARTH'S SWEETNESS

Past all earth's sweetness and accord,
Beyond desire and device,
The sacred mystery of Our Lord
Encompassed in a sacrifice.

No splendid palace to report,
Nor thundering statutes to obey,
But shepherds at his manger court,
A baby lying in the hay.

Christ in humility restores
What we have thrown away in pride,
Not with philosophy nor wars;
But cattle standing at his side.

No matter what the world believes
Is in its power to command,
All yet must kneel to receive
A blessing from a tiny hand.

NOW

i.

Called by the raging storm
Away from warmth and light,
They bravely fought their way
Into the raging night:
A climber on the fell
Mourning his wife, new dead,
Had spurned the Christmas cheer,
Seeking silence instead.

A burst of sudden grief
Induced a grave mistake,
He tumbled off a ledge
And felt both femurs break:
The weather worsened fast,
They almost turned away,
Hoping to start again
Prompt at the break of day.

But then they saw a light
Hovering overhead
Which drew them to a spot
Where he lay, almost dead:
It led them up a slope,
Bearing their fragile load,
But promptly disappeared
When they regained the road.

The angel of the night,
In memory of God's Son,
Finished the generous work
The rescuers had begun.

ii.

O how I wish we could find you a bed
All year round and a roof over your head,
But all we have is this shed for a week,
A shelter of joy when the season is bleak.

Here is a mince pie, a glass of mulled wine,
After the pudding I'm sure you'll feel fine:
Jesus is optional; don't get distressed:
All he would want is your comfort and rest.

Time to go now, we will see you next year
(If you survive, which is doubtful, I hear);
At Christmas our donors are willing to pay
But when it's gone, the goodwill ebbs away.

iii.

Tiny Tim looked in the window,
Saw the horses in array:
Wooden heroes bound for children
At the dawn of Christmas day.

Tim sees tractors in the window
But, diverted by the bread,
Turns his mind from shining presents,
Wishing he could eat, instead.

iv.

Lonely at the window, no-one plays
In the street on this family day of days,
Surfing a shallow wave of photographs
Where everybody smiles but no-one laughs.

A cup of tea, perhaps an hour of heat,
The supermarket meal ready to eat.
Why are the programmes different tonight?
She has a sense of something not quite right.

She dozes in a bath of canned applause
Which has something to do with Santa Claus;
And then she sees the baby in the hay
And knows why it is such a special day
And, waking up, she bows her head to pray.

V.

Welcome, this is Bethlehem,
Postcards, please, or something small;
I am eight and make the money
With this makeshift, little stall.

We are trapped within the city,
Work is scarce and times are hard;
Just a trinket, something pretty,
Oh, you only want a card!

When you see your baby Jesus
In the cave beneath our feet,
Tell him how you love the stranger;
How you gave her food to eat.

He was one and we are many,
But we live his story here;
Outcasts in an occupation,
Just a little souvenir?

vi.

Borne on the wind, a distant bell
More like a passing than Noel;
Good news for all, angels proclaim,
His coming makes us all the same:

O Jesus, if you came now
Your coming would be no less bleak
Than then:
Kyrie Eleison!

You came, that we should make you lord,
But we have not renounced the sword
And, added to such wicked kings,
We make so much of trivial things:

O Jesus, if you came now
Your coming would be no less bleak
Than then:
Christe Eleison!

Too weak to overpower thrones,
In thrall to temples made with stones,
Our ardour gutters out of sight,
Renew it on this Christmas night:

O Jesus, when you come
May your coming be happier
Than then:
Kyrie Eleison!

vii.

One star much brighter than the rest
Shines out above the city lights,
Its strength more powerful than all lights,
God's love in Jesus manifest.

No strength of arms nor cunning arts
Can overcome his steadfast love,
But there is just one place for love,
Not in the stars but in our hearts.

viii.

When the world grows dark and silent
And the last email is done,
I go home with cans and bottles,
Ready for a little fun;
But I place a tiny crib
Next to the television:
Putting the baby Jesus into Christmas.

I don't mind singing carols,
Most Christmas songs are stale,
Reindeer, sleighs and Father Christmas
On their silly global trail;
So the manger and the shepherds
Add some richness to the tale:
Putting the baby Jesus into Christmas.

ix.

Please let me in, the night is cold;
The town has turned its back on me;
But in your window there's a crib
Recalling Christ's nativity.

I am not quite the child you see,
My clothes are rough, but I am calm,
There are such dangers in the street,
Protect me from pursuing harm.

I see you disbelieve my tale;
Don't close the door against my plea!
Because in spite of how I look
It is the Christ Child that you see.

x.

As grows the acorn, so the child,
The manger that became a cross,
The hope that will not cower beneath
The weight of frippery and dross.

In slums and shoot-ups, baths and bars,
The story penetrates the vile
Excess of hopeless, doomed escape
To bring a momentary smile.

I am your maid,
Your will be done,
To bear the Godhead's blesséd Son:
The poor raised up,

The proud will dread,
The rich dispersed,
The hungry fed.

Pride kneels before a tiny child
And shepherds, who have little pride,
Give what they have in thankfulness
To stem oppression's roaring tide.

There is no snow to dress the dirt,
No motive for the rain of crime,
But in this tale they recognise
Hope in the DNA of time:

Blessed are the poor,
Blessed are the meek,
The pure of heart, the frail, the weak:
I am your strength,
Rejoice in me,
My suffering will set you free.

For one brief moment in the year,
Thoughts rise above the grime and gold;
So thick the gloom, yet there is light,
So strange the tale, yet it is told:

Of how a baby, born obscure,
Addressed us like a flag unfurled,
To give cheerfully to the poor,
Crowning him ruler of the world.

SCARS

Light on the golden straw
Casts shadow on a face;
Blood on the earthen floor
Betrays the price of grace:
Frost in the starlit air
Tailors fine coats of rime;
Shivering in the false glare,
The child feels the pull of time.

Doubts of the things foretold
Adulterates good news;
Scars in the pallid gold
Are melted, and then re-fuse:
Tears in a young girl's eyes
Alloy of motherhood;
Far from Olympian skies,
God made of flesh and blood.

OLD AUSTRIAN HYMN

Written in Vienna, 3 March 2014

O thou whom ancient seers foretold
Would light the dark and heat the cold,
Of David's line and Jesse's stem,
The morning star of Bethlehem
For us to shine
Was meekly in a manger laid,
Not carried in a grand parade,
His honour guard an ox and ass
Who let the humble shepherds pass
To worship human flesh divine.

Whose might surpassed the power of Rome
To reign here in our humble home,
Against whose armies no defence
Could withstand simple reverence
For God made man:
Whose triumph over death was so high
As low was his nativity,
Whose unimagined hope proclaimed
His mission for mankind regained,
To finish what his birth began.

Jesus, the wonder that you shared,
Our flesh can never be compared
With any other gifts of thine,
Though they are boundless and divine,
Not even grace,
For God incarnate moves the heart
In ways that words cannot impart;
This child exceeds all mystery
All creeds and all theology:
The logos in an infant's face.

BLESSÉD THE NIGHT

Blesséd the night,
Star-bright the sky,
Silence is pierced
By a new baby's cry:
High overhead
Angels pass by;
Mary is singing
A sweet lullaby.

Shepherds asleep,
Wake in a fright,
Thunderous words;
Mysterious light:
"Good news for all,
The future is bright,
Jesus Our Saviour
Is born on this night."

Blesséd the night
Hopeful the day,
Jesus lies next to
A lamb in the hay:
Wise men look out,
Still far away,
Trying to find where the infant
Will stay.

Blesséd the night
Hopeful the day:
Kneel at the manger
To wonder and pray.

THE CHILD AND THE BEGGAR

A white carpet for Winter,
And a crackling of frost,
A Christmas card picture
Whose beauty is lost
On the man in the doorway
Who shivers and prays
For a change in the weather,
The sun's pallid rays.

Wind cuts every corner
To savage the poor
Through cracks in the shutters
And under the door:
The new-born child shivers
And cries with the cold;
Even if he survives
He will never grow old.

The child and the beggar
Live under one star
Which illumines creation
Wherever we are:
Give warmth to the beggar
In the infant child's name:
Praise God in your kindness,
In thanks that he came.

PRO PASTORES

Simple, they say we are,
And some say outcasts, too,
But we are sprung of kings,
And Jesus is our due.

For, born of David's line,
A shepherd, king and priest,
He is our patron child
Who sleeps, warmed by a beast.

Magi may come and go
In costumes rich and rare;
But we will never go:
We will always be there.

SQUAD

Looking down from the sky
On a dusty old town,
Some sheep caught my eye
As I gently came down:
My angelic squad
All singing to God.

It would have been dark
So we made it gold bright
With a heavenly spark
For the glorious night:
I shouted "Good news"
Which was met with abuse.

I know shepherds are tough,
With a penchant to mock,
And the way we arrived
Was a bit of a shock:
But hard cash for booze
Reinforced the good news.

We sang them a chorus
To finished the show
And said spread the news for us
To those down below:
They were all so perverse
Pig-hands wouldn't have been worse.

JUST A LITTLE STAR

Just a little star,
Nothing very bright,
Breaking through the cloud
On a rainy night.

Just a little lamb,
Taken from the fold
Bleating for a smile,
Something warm to hold.

Just a little child,
Not an emperor,
Bringing love and hope
To the weak and poor.

Now a mega star
Lights our shepherd king,
Child and lamb and star,
Lord of everything.

SOMEBODY OUGHT TO KNOW

How the cold knifes through the wattle,
How the wind heaps up the snow,
How the straw tickles and prickles
In the candle's guttering glow:
Where have these poor strangers come from?
Somebody here ought to know.
I hear the cry of a baby,
When are they going to go?

Have you ever seen such a bright comet
As that hovering over the byre?
Just listen to those shepherds out there
Shouting as if there was a fire!
The youngest, there, what did he say?
Something crazy about the Messiah,
Good news for poor people like us,
Announced by an angelic choir.

MY LULLABY

La-la la-laa,
Sleep for a while,
And when you wake
We shall both smile
For we were born
Each for a trial.

La-la la-laa,
Dreams bitter-sweet:
What was proposed
Must be complete;
A mother stands
At her son's feet.

La-la la-laa,
Wake to the cry
Of angel-song
Passing us by:
What of me when
You go back to the sky?

La-la la-laa,
My lullaby.

A CHURCH IN BETHLEHEM

A church in Bethlehem is razed,
Leaving no stone upon a stone,
No sign that this was sacred ground
Where mercy was both sought and shown:
The Sunni storm will not blow out
Until Christ's legacy is blown
Body by body into pulp
So that His name will be unknown.

STRANGE COMPLICITY

Sweet infant sleep to shun the cold,
To spare you from the soldier's tread.
I'll sing a lullaby of old
And watch you in your humble bed:

How prophets with their blazing eyes
And crazy ways foretold your birth,
Of how through me you would be born
The King of Heaven to save the earth.

I wonder if I would have given
Consent to the bright angel's plea
If I had known we would be here
In exile, cold and poverty.

But I will sing the lullaby
Born out of strange complicity,
That you are what they say you are,
The Messiah of all; and me.

THE COMFORTER

Although the harrowing cries ring down
The ages as their mothers cry,
Herod's is but a petty crown
Which caused the Innocents to die.

The baby that escaped his wrath
Has checked the wrath of countless kings,
Directing them along the path
Of self-denial and suffering.

No general has had such troop,
No emperor such mandarins,
No love so humble when it stoops
To pay regret for faults and sins.

His parents carry him in flight
As soldiers torch their empty home,
Yet he will overcome the might
Of ancient and imperial Rome.

Yet, though it seems to quail before
The might of secular estate,
Love is the ornament of law,
The comforter that will not wait.

ENTWINED

Strange skies bring trepidation,
The promise taking time to crystallise;
Each minute calculation
Attempts to curb the margin of surprise:
And we, all stirred by nagging discontent,
Look up again and wonder what is meant.

Strange roads bring aggravation,
Graft far outweighing hospitality,
Sneering and provocation
Enhancing moments of sincerity:
But we, now star-ward driven, never look back,
Gripped by the prospect, not by what we lack.

Strange smiles bring consolation,
For what appears an inauspicious end;
We kneel in veneration,
But wonder what conflicting signs portend:
Death and new life entwined upon his chart
A dismal finish for a glorious start?

OLD CHARTS ROLLED UP

Our sought Messiah found,
The end of all our wandering,
A project bold and grand
Complete, a child slumbering.
Our garish gifts,
Products of so much posturing;
Pomp, war and death,
Statements much more than offerings:
Yet we are rich
In wisdom for our home-coming,
Old charts rolled up,
For a new beginning.

AH YES, A LAMB!

Ah yes, a lamb!
For which there is no mercy nor regard,
But if it is lucky a fleeting affection
Before its blood is poured.

Ah yes, a shepherd!
From whom so many stray for power and gold,
But if they are sorry for a fleeting moment
All will be reconciled within his fold.

THE END OF MAGIC

Stop for a prayer
To mitigate some feared riposte;
He is not there
To compensate what you have lost.
The Saviour's care
Puts God and humankind in place;
In full repair,
Magic is overcome by grace.

PROPHETS

From where you are,
Half desperate in the dark,
Can you see one bright star,
The Messianic spark?

He is what drove
You to such desperate speech,
A bow of love,
Shining beyond your reach.

Power and wealth?
No warrior, nor a king,
Who gave himself:
A perfect offering.

Now content rest,
Your prophets' work is done;
Israel is blest
In Jesus, God's own Son.

CONVERSATION

Where is the new-born child
Born long ago?
Is he a little lamb
Lost in the snow?

Nay, all the stars proclaim
He is alive.
He lives in David's name;
He will survive.

Send soldiers after him
And all his peers;
May David's lamp grow dim,
Sodden with tears.

Though blood flows in the street
That lamb has fled,
To sit in David's seat
When you are dead.

ALL WE KNOW

It would be strange to see a red
Rose petal on the snow,
Easier instead
To see a snow flake drifting
Towards gore:
Yet the rose
And the blood
Re-oriented
Godhead and motherhood.

It would be strange to see a star
Obscure all other light,
Easier by far
To see thousands of stars bright
Autonomously:
Yet the star
Of the stars
Created
Wonder and harmony.

It would be strange to see a white
Rose petal on the blood,
Easier, in spite
Of sophistry, to see blood lying
On the snow:
Yet the petal
And the star,
The blood
And not the snow are
All we know.

HOW?

How shall a rose so fair and full as this
Bloom in the depth of Winter?
How can a stable radiate such bliss?
Pray, may we softly enter?
The mystery veiled in mundane things declares
God in all things,
Answering our troubled prayers.

How shall a child so weak and poor as this
Blossom in hail and thunder?
How can God's Son fall to a traitor's kiss?
Pray, may we stand in wonder?
The mystery of the child who will not die,
From earth-bound chrysalis
To heavenly butterfly.

OBSCURED

Brave sages by a star
To Bethlehem were led
With gifts both rich and rare
To honour what they read;
Yet if the weather lifts
Will we then brave the street
To bring ephemeral gifts
And lay them at your feet?

The icons of desire,
Blinking with cheerful light,
Dissemble to inspire
And turn out to be trite;
History repeats itself
But we prefer the freak;
Our books stay on the shelf
As we pursue the chic.

Yet for all of our sins
—Which we would not call such—
When Christmas time begins
Our hands relax their clutch;
The manger child commands,
Obscured by glitz and glare,
The opening of our hands,
Though we don't know he's there.

LUKE'S LULLABY

Far from our comforts,
Out of the way,
Here you are lying
Upon meagre hay.
Not like the angel
Implied it would be,
Israel's Messiah
Born in poverty:

Long journeys over;
Back to the loom,
All the dear things
In our own little room.
Sharp the priest's warning,
Sharper by far
That my heart should bleed
Because of who you are:

Manger for cradle,
Such a wild start,
Rock with my singing,
Rock in my heart.

Manger for cradle,
Routine restored,
At least for the present,
My son and my Lord.

Think of the angel,
The star shining bright:
Laugh with the shepherds,
Jesus, Goodnight!

ECOLOGY

As polar ice crept down the glens,
Stretching its claws across the fens,
Our Christmas pictures turned from sand
To snow across the Holy Land.

Now, with polar catastrophe
Drowning the fens in rain and sea,
Will cards, now digital, please note,
Depict the manger on a boat?

If, then, the climate change extends
So that the temperate rainfall ends,
Will Christmas in the Holy Land
Revert to barren rock and sand?

SCIENCE

Through the bright mayhem of desire
And the cacophony of will,
A child's cry probes an awesome sky,
And, for a moment, all is still.

Through shallow fact and deep mistrust
Of anything man cannot prove,
A choir of angels stills the rage
Of self regard and sings of love.

And through the glitter of the age
Where light dispels a lurking fear,
A smoking lantern in a cave
Announces Jesus Christ is here.

As God's desire we are too grand
To be reduced to simple proof,
The mystery of why we are
Brings us much closer to the truth:
Science cannot prove but should discuss
God clothed in human flesh for us.

SOMETHING FUNNY INSTEAD

Why do they put church on the telly?
When they know that religion is dead?
Hand me the remote just a minute,
To find something funny instead.
Yes, I know that it wouldn't be Christmas
Without Jesus lying in the straw,
But it's only a story for children
Nobody believes any more.

HIS BABY HAND

His baby hand that clutched at straw
Was nailed against coarse wood for me,
Thus, being born an outcast waif
Was the least of his infamy:
The infant eyes that closed in sleep
Grimaced in pain to set me free,
The exile from King Herod's wrath
Was suffered for my liberty.

His cry that crept into the night
Screamed in distress with every blow,
The breast he sought for nourishment
Shuddered with grief to see him so;
The body wrapped in swaddling clothes
Too early wound in bands of woe:
And yet God's Son who died for us
Is God and king of all we know.

CHRISTMAS TUNE

Approximately after Paul Simon's American
Tune, *approximately after Bach*

It's not so much the snow of Winter,
Nor chestnuts on the fire,
Nor yet the clementines and walnuts
Of long constrained desire;
But the close-knit understanding
Of what's going on I miss:
Remembering Jesus in a stable, cold and dark,
And a snatched mistletoe kiss.

Now that the presents in a pyramid
Won't fit below the tree,
Perhaps because Jesus Christ and Santa Claus
Have lost their mystery?
Or maybe we enjoy too much
Of what we want the whole year long,
In spite of all the surface bonhomie,
There's something going wrong.

What makes things special is their difference,
Not heaps more of the same,
So in our down-to-earth enslavement
We need a simple game:
Call it Santa or Jesus,
We need something to believe,
And if we forget how to understand ourselves,
The world will be left to grieve.

AS SIMEON SPEAKS

As he foresees her pierced heart,
Turning our minds from crib to cross,
The age of innocence is cut short:
A sad but necessary loss.

For this is when the magic ends,
The sweet grown sad, the dark grown dense,
The wonder child by human hands
Is murdered for his innocence.

And she who holds him here today,
Simeon says, will hold him again,
A mother seeing her baby die,
Praying for the death to end his pain.

And we, like children, mourn the loss
Of candles, and then walk away,
Bypassing Jesus on the Cross
To meet him next on Christmas Day.

EXCESS

Bring straw for tinsel laid within a manger,
Where there were twinkling lights, a great star shines:
That tree so bright with baubles bears our saviour
Who dragged his wooden sleigh across the stones.

Crimson Santas bring good news dressed as shepherds,
While in-store wizards seek a hidden king,
The schmaltz of malls turns into wistful carols
So that we stop and listen to the song.

The child who came before the light and colour,
Bringing new hope, not frippery and dross,
Smiles at our gaiety with calm indulgence,
As he surveys our excess from his Cross.

NEW YEAR

Pianissimo
Time to go
Status Quo
Clocks slow
Red lights glow
Debts grow
Neighbours know
Spirits low
Patches show
Dead mistletoe
Bins overflow
Santa dumped in dirty snow.

VOLUME V

ALL HAIL THE GLORIOUS NIGHT

2019

PREFACE TO VOLUME V

Never say "never", but I am as certain as I can be that this is my final collection of Christmas poems with the dual purpose of being read for themselves and offerings to composers looking for new seasonal words. The clue is in *Posada, Winters* and in the Epilogue. I have always written in massive creative bursts that have subsided as suddenly as they have erupted and my current overriding creative activity is writing longer poems.

Perhaps, too, there is a sense of ending with the sad and premature death of Alan Smith, the composer who set far more of my poems to music than anyone else and to whom this book is dedicated; probably the last work Alan completed was setting two of my carols from earlier volumes.

Reviewing the manuscript I was struck by how much material deals with the implications of Christmas rather than the story itself and I am pleased by this because I feel that Christians are in danger of losing this sacred festival in the wake of the loss of Easter. What, then, will be left?

Kevin Carey
Hurstpierpoint, West Sussex
Ascension Day 2017

GO, GABRIEL! GO!

Go, Gabriel! Go! And choose the brightest star
To herald the arrival of my son,
Sent down in solidarity with man
To finish the creation I began.

Set it above the place he will be born,
To draw the magi onward to his side,
A humble place, bereft of earthly pride,
Fit for a man who will be crucified.

SPINNING

In the beginning
A maiden spinning,
A sound that makes her shake,
Causes the thread to break,
She bows her head against the opening door
Seeing the light that spreads across the floor:
Uncertain of the emotion she feels,
Meekly, she shades her eyes and softly kneels.

"Let me begin
My thread to spin
Which, if you will now take,
Surely will never break:
'The Word made flesh' in you is my request
Carried direct from God at his behest."
Certain of God but still not knowing how,
Bravely she stands to make her sacred vow.

"What God begins,
The servant spins;
As he is ruler of both live and dead,
He has the power to make or break the thread."
"God's Spirit within you will realise
His message to you beyond all surmise."
And in the familiar darkness of the room,
She felt a fire kindling in her womb.

ENCOUNTER

"Peace! Do not start!
I love you on my Master's part
With all my heart."

"Light's ecstasy
Sunlight through flowing honey
Falling on me."

"Sweet maiden blest
Pray, make Messiah manifest
At your young breast?"

"Maid as you say;
Yet God will find the proper way
For his baby.

"Thy servant small
Whose body quivers with His call
Shall not fail.

WHY ADVENT?

The longest term bursts into Advent flame;
A purple candle in a hollied frame
Proclaims the promise of a life renewed
Too robust for the grim church to exclude.

Then home to the brass band on Christmas Eve
Before the civic crib set to receive
A baby as our common gift that each
May stretch and touch, a God whom all can reach.

More human to await than to arrive,
More faithful to delay than to receive;
Anticipation keeps the soul alive
Fulfilment is much harder to believe.

Age makes my childhood feeling more intense,
The shrinking world makes Jesus more immense:
In spite of promise, longing is more real
Than anything the angel will reveal.

PENITENCE

Halloween and Guy Fawkes gone,
Christmas advances like a wave
Black Friday at its early crest
Carrying us along to spend to save.

Then after candle-lit new year
Advent enjoys a week at best,
The radio filled with Christmas carols
So we are full and early blessed.

The party season in full swing
Cements work and communal ties
It would be churlish to ignore
Resorting to pious reveries.

But Oh! How hard it is to turn
In penitence for Jesus' birth,
Remembering why and what befell
When he came down to us on earth.

THE OLD SHEPHERD

One must remain to watch the wandering sheep
Placid again, the angels gone away;
It was the boy or ancient me they said
By drawing lots for which of us must stay.

I would not draw but said the boy must go,
Enough of joy and sorrow I have known,
What more than angels bringing God's good news
Could I desire, his mercy to be shown?

That night, not knowing when I was asleep,
I think I dreamed the angels came again,
All kneeling down before a golden child,
Proclaiming him Messiah born to reign.

The boy awoke me with a brother's kiss,
Not far behind I heard the others call:
He told his story, I told him my dream
Of how the Christ had come to save us all.

ALL HAIL THE GLORIOUS NIGHT

1. All hail the glorious night
Golden as summer's day
With angels shining bright
In heavenly array:
Good news for all the meek and poor;
Jesus shall reign for evermore!

2. All hail the joyful maid
Who held Christ at her breast
Then in a manger laid,
His sacred head caressed:
That such as us should heed the call
To bear our Saviour, Lord of all.

3. All hail the Prince of Peace
Born in such lowly state,
The key of our release,
The key to heaven's gate:
Christ will return to claim his own,
All earthly powers overthrown.

4. All hail the three in one
Rapt in that lowly place,
The Father looking on,
The Spirit showering grace:
Let Christmas bells in gladness ring,
All hail to our redeemer king!

ON THE FIRST CHRISTMAS NIGHT

On the first Christmas night
As its folk settled down
For the evening a lady reached
Bethlehem town
Where the inns were all full
But one innkeeper said,
There's a stable out there
If you must have a bed.

On the first Christmas Night
That young lady gave birth
To a boy who was ruler
Of heaven and earth
But the first to whom this
Mighty deed was revealed
Were poor shepherds who dozed
With their sheep in a field.

On the first Christmas night
They awoke with a start
As the darkness by angels
Was riven apart
Who said there was good news
For all people in store
But this would be most of all
For the weak and the poor.

On the first Christmas night
They abandoned their sheep
To adore the young child
That was lying asleep:
And on this Christmas night
Let us all do the same
Because it was for us
That our Saviour came.

THE MANGER

I never had the strength to be
A cross to bear a man's distress,
The office of a public tree
For carpenters to saw and dress.

Knocked up from outcast wood I bore
An infant's weight for sundry hours;
When he was lifted from the straw
I wanted to break out in flowers.

They say his cross was found at last
While I dissolved back into earth;
Yet I am recalled in what passed
When children speak of Jesus' birth.

MARY'S GREETING

Step light, young lads,
The baby is asleep,
Thanks for the joy
That brought you from your sheep:
A light so bright
It even dimmed the star?
What was the voice
So near and yet afar?

Good news for all
But chiefly for the poor?
Those were the words
My angel said before.
See how he stirs
As if he knows the price
Of such good news
Is deadly sacrifice.

Look, he awakes!
Was ever such beauty seen
As in his smile
So gentle, yet so keen?
A little lamb?
Why, that will warm and cheer
My little lamb.
Thank you for coming here.

HOW SHALL WE BE JOYFUL?

Sent down from heaven into time and space
announced by the appearance of a star
yet in a stable crying where we are
from heaven he came, yet of the human race.

By Mary carried of her own free will,
Consenting that the Spirit should instil
within her spotless flesh the sacred seed
that God in man should live in word and deed
that all the prophets' words might be fulfilled.

Emmanuel, God with us, welcome here,
whom shepherds and the magi both revere,
laid in a manger, sheltered from the cold,
A tress of straw and not a throne of gold,
we with them kneel and worship one so dear.

Our Alleluias in a minor key
speak of our sorrow in our frailty;
for how shall we be joyful in our song
when what began so sweetly went so wrong?
Only that by your death you set us free.

WE WONDER

Here is the place.
Hush! Do not wake the child;
In heaven's embrace,
Humble we are strangely beguiled.

Made drunk with light,
Charmed to Bethlehem with words
Hope dressed in fright
Why given to shepherds?

We are God's nobility.
David was a shepherd boy:
His offspring here humble as he,
The whole world's joy.

When after years our weary watch we keep,
Recalling how we left the sheep,
We wonder if we were asleep!

WALKING AWAY FROM BETHLEHEM

Visions and dreams
Isaiah saw
Pointing away
From measured law
Towards a child
In Bethlehem,
To seek the poor
And gather them.

Yet we who see
Him laid in straw
Are still too fervent
In the law;
We leave the poor,
Condemning them,
Walking away
From Bethlehem.

ALWAYS

Across the sky
A rapture is rolling
Of angel song
Announcing your birth:
God's child come to earth
Needs a lullaby
Lullaby, lullaby
Lullaby!

Across the ground
A messenger pounding
With warning of
A murderous king:
O what suffering!
Darling, do not cry
Do not cry, do not cry
Do not cry!

Across my heart
I feel the pain growing
Of earthly anger
Thrown at my son
Holy one
Abba, hear my prayer
Hear my prayer, hear my prayer
Hear my prayer!

I will always be there.

FIRMAMENT AND CHARTS

Stirred by the night sky's strange array,
Working out what the charts might say,
The wise men gathered gifts to bring,
To set before a new-born king.

Steered by the star they reached the place,
Greeted by Mary, full of grace,
Laid gifts and reverence at His feet,
Before a hurried and shamefaced retreat.

Stored in their souls when shame and ardour cooled,
Their awe showed in the way that they were schooled,
Routinely scanning firmament and charts,
The infant lodged forever in their hearts.

SAGES

Far away in the mysterious deep
 A sage is knowing,
A strange light tinting the horizon
 But not yet showing;
Then raising eyes without surprise
 He sees it glowing.

In an old book rarely read
 He seeks a saying,
In old Isaiah he discerns the truth
 Of the light's displaying;
The shoot from Jesse root proclaims
 No time for staying.

 From divers places other sages glean
 The meaning of the prophet and the light;
 Travelling to Bethlehem on a holy night.

Gold for an infant king
 Whose wealth is dearth;
Frankincense for a priest
 Whose heaven is earth;
Myrrh for the corpse of a saviour
 Whose life is death.

JUST ONE STAR

Is that all? Just one star
For our salvation history?
So bright, but only one,
To celebrate the mystery
Of God made fully man
Yet born as weak as you and me.

Is that all? Just three kings,
Or wise men, gathered at his feet
To worship and present
Their gifts before a swift retreat;
Invisible until
They kneel before his mercy seat.

Is that all? Just a lamb
To comfort him, trembling and slight?
Yet, he being a lamb,
Its bleating filled him with delight;
And shepherd also he
Was with his own that sacred night.

THE TRUTH SHINES BRIGHTLY THROUGH

The midnight peace of Bethlehem
Is broken by a cry,
So quiet it is only heard
By ostlers passing by
Who knew the strangers' story
But supposed it was a lie.
They little thought that they could hear
Messiah, born to die.

The shepherds' intermittent doze
Was torn by blazing light
Followed by tidings of good news
Which caused them to take fright.
But when they got their story straight
It seemed to come out right.
The baby was there, right enough,
Though its prospects were not bright.

Three wise men poring over charts
Thought they saw something new
And, being scientists, they said
That it could not be true.
It was only when they found the child
That they modified their view.
In such unlikely incidents
The truth shines brightly through.
The truth shines brightly through.

FOLK SONG

Great sages from the Orient
Set out to see a king,
To be proclaimed in Bethlehem
By their fair reckoning:
But when the great star came to rest
Upon a humble shed,
They found the infant lying in
A feed trough for his bed.

Haunted by dreams they laid their gifts,
Prayed hurriedly and fled,
Back to report the joyful news
Just as King Herod said:
But in a dream an angel said
That they must not return
Because the king would surely act
Upon what he would learn.

Fierce Herod sat upon his throne
To hear the dreadful news
That he now had a rival to
Be called king of the Jews:
His courtiers quaked beneath his gaze,
Then heard his fearful cry
That the mildest man who ever lived
Was surely bound to die.

The busy angel warned Joseph
Of what the king had planned,
So Mary, Joseph and the child
Were forced to flee the land:
No sooner had they taken flight
Than soldiers made it plain
That they would ransack every house
Until all boys were slain.

Now all who hear this sorry tale
Should mourn the gruesome loss
But had they lived and Jesus died
Then there would be no Cross:
So praise the earliest martyrs for
Their murder, so depraved,
Which meant that Jesus died for us
So that we might be saved.

THE CLOCK

The clock of time across the sky,
Though constant, seemed to run too slow
Promising nothing to relieve
The wait they had to undergo:
But now a bright new star appears,
Quickening time with its display,
Isaiah bursts out of the gloom,
His baleful brothers sent away.

Yet when the evidence is in,
Exhibits fail the prophecy;
Talk of a baby laid in straw,
Only a band of shepherds see:
Rumours of angels met with doubt,
Too many prospects unfulfilled;
Census officials pack their bags
Completing what their Caesar willed.

Yet hope survives in spite of doubt:
The shepherds stubbornly persist;
Some say that wise men have set out
To set their seal upon the Christ:
Then infant blood engulfs the town,
Confirming what the old men feared;
All sink back into blank despair,
Worse than the day the star appeared.

AT OUR SIDE

Where the sea is black,
Where the sand is brown,
Where the buildings shake
At the edge of town:
Here a daub of red
There a rag of blue
Tell us and the world
That we welcome you.

Where the shells are shocked,
Where the ground is crushed,
Where the bodies lie
As the guns grow hushed:
Here a broken tune
There a childhood word
Sung to welcome you
Can almost be heard.

Ah, the cruel sea
And the cruel ground
Stained with endless tears
Shed without a sound:
Though we fire at you
Across the broken land,
When we turn away,
At our side you stand.

URBAN SNOW

No peace like urban snow,
More wonderful than in the wild,
For silence and cold glow,
Hushing the earth for a new child.

No light like star unknown,
More wonderful than charted light,
Illumining a manger throne,
On a clear night.

No sound like angel sound,
More wonderful than Bach's cool fire,
Bringing good news not found
In gratifying earth's desire.

No love like Jesus' cry,
More wonderful than poetry,
Born for us all in poverty,
The sweet "hello" with no "goodbye".

BALLADS

i.

Why is the moonlight
Equal with star bright
So that both shine equally clear?
Why is the choir
Shining like fire
Sounding so far yet so near?

The infinite divide
With God and us on either side
Is bridged by beauty past all rhyme:
The answered prayer
From Bethlehem to everywhere
Has changed creation for all time.

Why is a flower
More full of power
Than the whole world's stock of bling?
Why is a baby
Better than maybe
God, when we looked for a king?

ii.

Light upon a lady
Bright as angel glow,
Dark upon a baby
Sheltered from the snow:
Fear upon the shepherds,
Voices from on high,
Star upon the wise men
Softly passing by.

Humble was the lady
In the angel glow,
Quiet was the baby
Quiet as the snow,
Exultant the shepherds
Carrying their news,
Cautious were the wise men
With their learned views.

Long after the shepherds
Vanished in the gloom
Long after the wise men
Went quietly home,
The lady keeps her smile,
Forever bathed in light,
The baby leaves the darkness
To put the whole world right.

iii.

In a quiet lullaby
A lady sings the blues
Careless of the sky
Looking at her shoes.

In a sparkling summer song
A lady sings with joy
Of right conquering wrong
In the person of her boy.

In a searing threnody
A lady sings with grief,
Of things not meant to be
In her shaken belief.

In a song beyond all songs
A lady sees her Lord,
Brought back where he belongs,
Once taken, now restored.

IF I KNEW YOU

If I knew You as a lamb,
Laid in straw where shepherds came,
Spotless as a Temple ram,
Carrying the whole world's blame:
Then I would be mortified,
Seared with heart-bursting shame,
Grateful and yet horrified
That it was for me You came.

If I knew You as a lamb,
I might yet in some degree
Come to view with proper shame
What You offered up for me:
You my shepherd, I Your lamb
Grazing in humility
Bleat beneath Your loving hand,
Now and in eternity.

FAMILIES

i.

A carol brings a tear:
He checks the turkey burger on the stove.
Another lonely year.
The crayon drawings all that's left of love.

The picture makes him cry:
A family with shepherds and a lamb;
The gifts piled high
Are opened as he hears the front door slam.

The silence makes him pray:
The words for what he did have lost all force;
To face another day
The new born child is his only resource.

ii.

Jesus, send a rain man
To blow the clouds away
Uncovering the starlight
When I kneel down to pray;
And then send down the snowflakes
When I go out to play
On your special day.

And please send me a father
To frolic in the snow
Instead of just a name tag
That I no longer know
To help me build a snowman
And set my cheeks a-glow
If not now tomorrow.

I know that I should welcome
Your birthday ever year
But it only brings sadness
And, like as not, a tear;
I feel a special sadness
As your special day draws near:
If not now, next year.

iii.

For all the wrong choices
I lie here in the straw,
For all that is to come
And all that went before,
Bringing love to suffering,
And mercy to the Law.

The weakness that you look on
More like you than a king,
The flight that lies before me
Chimes with your suffering;
Look past the present moment
To see the hope I bring.

ESSENTIALS

Incarnate in winter,
Smudged in the myth of snow,
Worshipped by shepherds
Suffused with angel glow:
But the truth of incarnation
Is all we need to know.

Surgeon in summer,
Dressed in the healer's gown,
Worshipped by blind men
Caught between float and drown:
Curing hidden symptoms
With power unknown.

Gatherer in autumn,
Wreathed in the fruitful mist,
Reaping the harvest
For the Eucharist:
Promising salvation
Where no-one will be missed.

Sufferer in springtime
flayed down to bone,
Reigning above us
On a murderous throne:
And without His suffering,
We would be alone.

Almighty forever,
Robed in eternal light,
The tomb gaping open
With glory and fright:
Without His resurrection
Death is eternal night.

BETRAYAL

The intricate perfection of a baby's hand
God clothed in human flesh, the sacred bond
Of love beyond what we can understand,
Yet mutilated by our wilful wound.

The wonder of being human in a baby's eyes
With hope that pride and callousness betrays,
No wonder that the seeing organ cries;
Tears will give way to blood which by us flows.

The unsure palpitation of the new-born heart
Steadied by milk attains an even beat
But it would race to bursting at the start
If it knew how we would inflict such hurt.

What treachery to break a blessing hand,
What infamy to dim such radiant eyes:
What retribution for a loving heart
Which repaid with salvation what we wrought.

POSADA

Almost lost
for more than two hundred years in a cloud
of dust, a young man with a staff, a donkey and
a maiden last seen on a Judean road, found
in Alexandria, although
the Lucan clues had been obvious enough, led
into a crumbling marble atrium with Sapphic
scraps and an etching of Isis, as yet bereft of shepherds in
this land of grain and brick, not knowing whether
this was an incarnate valediction in the Gnostic fashion or
a beginning, the maidenhood of Mary asking
the question.

Transported to
the self-regarding pomp
of introvert Byzantium and the faded glory of once
Imperial Rome, carried along
anachronistically proud and knife-through-butter roads
gone green, with shepherds driving towards pasture and away
from
the next wave of those who sought to settle
where they had come fifty years
ago, arriving at last in lands
of mire and mizzle where, there being no caves, wood
was hacked for shelter and where straw lay thick upon
the earthen floor.

Miracle of the virgin
Theotokos, representing all that
was soft and good, nearer to us than
God above or the wondrous host, in her meek motherhood. How
quaint she looks, migrated from the forest of wood to the forest of
stone, dressed in fine red raiment, before the age
of blue, surmounted by a golden halo, yet
where the fighting was most fierce for Byzantine
survival, conquest of the infidel or
an upstart king it was for Mary that they cried, and not
for Christ.

Retribution,
when it came, was swift and brutal, as it always is
when personal gain poses as principle, the axe
falling, almost killing the baby to murder his mother, collateral
damage to quell the excess of unastringent piety, in the name of
a higher doctrinal purity and the death of
invocation for the dead, all comfort gone, all
usefulness for those gone before indicted, only the cross
is left, the prim and parsimonious sweeping
North until Scotland was rent of Christmas and
Merrie England sent into a state of
permanent melancholy.

Southwards
in blue and gold the bright procession went, with shepherds
following close, their sentimental arms
in conflict with their wrestlers' thighs, then purple
monarchs staring at the sky and Herod
much more wicked than before, and all in impossibly beautiful
Italian light; and then across the tamed Atlantic to
the sound of dancing never heard before, the infant God, first
ghostly white, lit by strange fire and showered with
the puzzled prayers of shattered dignity; how
could a child like this have brought
calamity?

The perfect
intricacy of the new-born baby's hand that
would not be denied, found
favour where resistance was most sharp, where the shadow of
the Cross had made all things dark, in starched
New England and in Germany where Christmas
music, so long exiled to the street, was welcomed
home to celebrate the crib; and then the accident of
climate change brought snow and sentiment, with bells and
candles, carols and surpliced choristers, as
Mary was brought home with babe in arms
to England.

Carried

from threadbare flat to opulence, from keen desire to

not wanting to be missed, puzzled by tinsel, sheltered under

trees, with songs of sleighs and Santa chuckling by, peering

at shopping lists and table plans to keep old spats

at bay, the donkey tends to gain the pride of

place, symmetrically framed between the young girl and

the ageing man, in a posada more of stress than

penitence, a struggling observance of tradition and family

history; and

yet through the vicissitudes of change, there is still

The Child.

POSADA SONGS

i.

Lost for two hundred years upon a road,
A cloud of dust in the Judean sky
Hiding a donkey with its sacred load,
The maid, Theotokos, then passing by.

What Luke had written patriarchs proclaimed
In secret first but then in cries of joy,
What tongues had whispered was now loudly named,
Messiah born for mankind as a boy.

Faded inscriptions steadily gave way
To images of Mary with a child
Laid in a manger on a bed of hay,
Brought into Alexandria from the wild.

ii.

Via introverted new Byzantium
And fading Rome the new story was spread
Advancing as the eagles were withdrawn,
Filling the space that had been left for dead.

Along the roads still proud that cut through rock
Like knives through butter, but now green, it went
Where marching boots gave way to ambling flocks,
And discipline to uncouth sentiment.

In churches of hacked wood and earthen floors,
With alien damp strange lichens garish spread,
The humble folk paid homage to the humble
With Christian hope alloyed to pagan dread.

iii.

See the lady dressed in red,
In a forest made of stone,
In her crib, as smart as lead,
Where the manger is a throne.
Hear the monks in solemn chant
Christmas narratives intone,
Soaring, arced polyphony
Flesh upon a modal bone.

See the lady dressed in blue,
Bright below Italian skies,
Celebrated in the street,
In new verse and melodies:
See the baby, plump and round,
Golden hair and sapphire eyes,
Blessing with his chubby hand,
Sparkling like a jewelled prize.

iv.

Swing the axe
Scrape the wall,
Listen to the statue fall.

Cut the head off
Sophistry,
Eradicate idolatry.

Smash the window,
White the wall,
Hammers drown
the siren's call.

Save the baby
If you must,
But his mother must
be crushed.

V.

Came across the sea,
Ships with wings of flame,
Violent and bright,
Different and the same.

Slaughter and disease,
Defeated and distraught,
Yet we came to love,
The God in child they brought.

Teaching them to dance,
For their new sacrifice,
Yet not forsaking fire
Exploding from the ice.

Consoled with what they
brought
For what they took away,
Our gold was all exchanged
For a baby in the hay.

vi.

Where doctrine had grown harsh, softness erased,
Yet was the infant's gentle tableau praised
In cantata and oratorio,
Angels on high and shepherds down below:
Kings wise and sumptuous travelled from afar
Urged forward by the light of a new star.

And where false pride and paranoia sprang
In homely carols thankful pilgrims sang;
Where witches seemed to threaten grace restored
The gentle presence of our humble Lord;
Grim silence broken by a peal of bells
As children sang their innocent Noels.

vii.

Revellers all come out to play
And try your skates this Christmas Day:
The frozen pond will not give way.

The goose is roasting on the spit,
With glowing chestnuts fit to split
A holly sprig adorning it.

The steaming punch bowl welcoming
Your toes and fingers tingling,
Inviting you to dance and sing:

So fill the festive hall with mirth,
In memory of our Saviour's birth,
Who lived among us on the earth.

viii.

Snow on the stable roof
A robin on a bush,
The raucous streets in Palestine
Turned to a reverent hush.

The sentimental leanings
Of the urban bourgeoisie,
Who would not want it for themselves
Venerate poverty.

The forest, now imported,
In the sparkling Christmas tree,
The eclectic and syncretic
In domestic harmony.

ix.

How shall I sing a lullaby
To my restless child tonight
Though the streets are loud and bright
I can hear so many cry.

How can I sing his happiness,
Reward for suffering,
For though they shout and sing,
The world is in a mess.

I love this child of love
Whose loving is sublime
Forgiving humankind
For its most grievous crime
Of killing Him
Who loved them.

How shall I sing his birthday song
With Santa and his sleigh,
Who smiles me on my way
As if I had done wrong.

The journey seems so long
Since in my arms he lay.
How shall I sing His song?

X.

Passed from manicured to shaking hand,
From threadbare cleanliness to opulence,
Amid the knowing and sophisticated,
A calculated splash of innocence.

Too clever to deny the tale outright,
To place a modest brake on Santa's sleigh,
The lady and the older man take rest;
Next morning they are sent upon their way.

Even in houses where night prayers are said,
The donkey is awarded pride of place,
Between the faithful Joseph with his staff,
And Mary, Theotokos, full of Grace.

xi.

There is still the child:
Fashions come and go,
Fortunes form and grow;
From on high sent below
There is still the child. There is still the child:
Empires rise and fall,
Heads fade on the wall,
Guards change in the hall;
Lying in the stall
There is still the child.

There is still the child:
To whose love we cling
Born of suffering,
For whom church bells ring,
He of whom we sing,
Jesus Christ, our King,
There is still the child.

WENCESLAS

Councillor Wenceslas nipped out
For a pint and pasty
Where the snow lay round about
Heaped and grey and nasty:
Dimly shone the lamps that night
Where the thickest fog lay,
So he stumbled on a man
Lying in the doorway.

"Hither stooge and sort this out,
If thou knowest, telling
Yonder vagrant why has he
Not got his own dwelling?"
"Sir, when he was discharged from
Our country's great army
Trauma that he suffered from
Quickly drove him barmy."

"Rouse him with your walking stick
From his drunken stupor.
Hello, is that the Police?
Nice to hear you, Super:
You should clear our town of scum,
Keep it disinfected,
Businessmen can only thrive
If it is respected."

"While your profits rise and rise
 All the rest are falling,
 Cuts to social services
 Really are appalling,
 Cuts to justice and police,
 Health, welfare and wages;
Destruction of the working class
 Is in its final stages."

"Liberal rot from the police!
 Just keep law and order.
 And kick all the foreigners
 Back across the border:
 Get rid of the nanny state,
 Westminster and Brussels,
 Cut taxes and cut red tape
 For the man who hustles."

While he shouted down his phone
 On his own condition,
 The poor soldier at his feet
 Died of malnutrition:
 So the moral of this tale
 Set in winter weather
Is that in spite of what they say,
 we're not in this together.

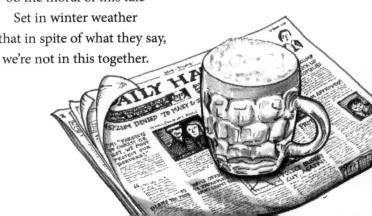

CREATED FROM ETERNAL LIGHT

1. Created from eternal light,
Incarnate God come down to save
Us from our necessary flaw
By rising to defy the grave.

2. Imperfect though we are where He
Was perfect in His human form,
His solidarity with us
Outlives our crucifying storm.

3. Child in a manger, God in tears,
Dependent on the breast he made,
Blessing the bread of Adam's toil
Then into His own body made.

4. Great is our joy as He was small,
Such wonder in a baby's hand
That plucked his mother's cloak as if
She were the sum of His command.

STRANGE LIGHT

Look, stranger, look at the strange light
Fire flameless in the dark,
Whence came the blaze that tore the night,
What was the secret spark?

Now it spreads out afresh, afar,
Over the frosty field;
Then it is gathered in a star,
What secret will it yield?

Now it is glistening in gold,
Then sweet with incense rare,
Whatever secret it may hold
Will surely end in myrrh.

It is a light that will not fade
Now that it has begun;
It is by God forever made
In the gift of His son.

DUSK

A scar of blood across the snow
After the sunset's afterglow:
See how the crimson dully glows
After the brightness of the rose.
The azure of declining day
Is masked by the onset of grey:
Yet the brightness of future days
Is promised in a star's bright rays
Which return everything to white
Defying the onset of night:
Blood there will be but it invites
Hope that all will be put to rights.

SHORT STORY

Long
On the crooked road
Fragments of a song
To assuage the load.

Remote
In the grudging straw
A first, feeble note
Of a song for the poor.

Killed
In the blood trade
So unfulfilled
In her arms he laid.

Blinded
With Easter light
She was reminded
Of that first, dark night.

BROKEN HEART

What sage can match that infant cry?
What wisdom can that scene reveal
Where in a tableau coarse and angel bright
Bewildered shepherds humbly kneel?

For too long they have taken you
To palaces where you would not be
Who chose a stable to reveal yourself
directly to people like me.

The kings were late, priests later still,
Bringing their different kinds of ill,
My heart the palace where you came to live,
Where I could humble shelter give.

Yet as the great and rich possess
Their special flaws, mine threaten too
The heart I offer, broken but mended by
Your broken heart, to welcome you.

CHRISTMAS 1914

As Stille Nacht instead of shells
Fell into Tommy's trench
Listening to left and right he heard
The First Noel in French:
And as he hummed he realised
That men were all the same;
It wasn't them but London toffs
Who had to take the blame.

Prayer would have been enough for him
Although he did not pray,
Better by far to re-enact
The joys of Christmas Day:
Yet he admired the common touch
Of football in the mud
As long as nobody believed
It would do any good.

But when he opted for the watch
And heard the whistle blow
He did not pray or think of Christmases
Loved long ago;
But welcomed calm and solitude,
A temporary release,
And struck a match without constraint
To light his pipe of peace.

INTERPRETED IN LOVE

All that there is from shoot to frowse
From bloom to blow
From beat to blood
Is tightly bound within the bud.

All that there is from Word to end,
From crib to Cross
From spark to fire
Is in the knot of God's desire.

All that there is from step to fall
From whim to will
From salt to clove,
all is interpreted in love.

FADED

Long after colours fade
The form survives,
Without the light and shade
It somehow lives:
The brain trained in the line
That draws the eye
Retaining in decline
Our sympathy.

Shepherds from quaint to
obscure,
No-one wise,
Authority unsure,
Ego the prize,
The halo dim,
The wonder leeched away,
So what of him
Still lying in the hay?

Who will apply new colour
To the faint
Or shall we shrink in horror
At new paint?
How will the story
In the picture glow
In glory
Of His lowly birth below?

NEVER ENOUGH

Just one more extra batch
Under my aching hands,
In vain I try to match
Her peer-propelled demands:
In spite of what she says
I dread she would prefer
The gifts my labour brings
To an extra hour with her.

Never enough to please
The naive optimist
I desperately scan
The ever lengthening list:
But as we both must eat
Her father will provide
The glittering presents
Have cruelly denied.

OFFERINGS

That wondrous night our Saviour came
All earthly rules were set at nought
A new made star and angel flame,
A stable for a royal court.

Where courtiers rustic as the reeds
With pipes and ewe lambs gathered round
To meet the infant's simple needs
And worship him, a king uncrowned.

Then diverse sages coalesced
To mark a greater wisdom where
The infant blessed quietly blessed
Their gifts prophetic, rich and rare.

The gold and frankincense condemne
The poor he promised to refresh.
Ah! Such a crown with sharp thorns stem
And myrrh with tears on broken flesh

Then shall we on this wondrous nigh
Eschew a kingly proffering
For what will give him such delight
Is our own selves as offering.

WAS IT FOR ME?

Such barren ground for peace
Such hostile ground for birth
And yet he eschewed ease
To grace his tarnished earth.

Such light was startling seen
Such tidings for the poor
As there had never been
Before.

Was it for me,
Such wonder and such woe?
I must believe
Because he told me so.

THE DAY AFTER TOMORROW

Amid the cheer
Never quite without a tear,
For he was outcast, cold,
Never grown old,
Not what the sages had foretold.

Knelt at his side
See what our childish habits hide:
The straw prickling and rough,
The shepherds tough
Kings who had had
more than enough.

On Calvary
Inside the dark and misery
A flicker of a smile ashamed to show
I know
The day after tomorrow.

UNFOCUSED

Unfocused eye,
Unprompted cry,
Cold I had never thought to feel;
The scratch of hay,
A lamp's dull ray,
A sad farewell to the unreal:
From heaven's home so richly blessed,
Come from the womb to take the breast.

Through restless sleep,
Dreaming of sheep,
Uncertain music sad and sweet;
Yet more sincere
The falling tear,
The lowering prospect of defeat:
My court in whispered disarray,
Broken before the break of day.

Unfocused I,
One last, hoarse cry
The end of earth's uncertainty;
My cross the key
To liberty,
Returning to eternity:
Yet God in concrete manhood came,
Nothing again can be the same.

UFFIZI

Florence, May 2015

Medici by the hundred stiffly kneel
To haloed babies plump and pink as veal;
As if the Christ-child's favour could be bought
By those who condescended to pay court.

No shepherds here, nor sheep, the pastoral
Limited strictly to the classical;
God for the settlement of marriage deeds
Protected from the sight of humble needs.

Yet even the most splendid empires fall
As war, greed, lust and gambling take their toll;
Yet Tuscan shepherds still look out for danger
And bring their simple offerings to the manger.

JESUS, INCARNATE GOD OF HISTORY

1. When I am called, may I reply in haste,
Like Blessed Mary, heedless of my taste;
Giving myself as you were given for me:
Jesus, incarnate God of history.

2. When you cry for me in the threatening night,
May I respond with all my feeble might;
Grateful for all that you have done for me:
Jesus, incarnate God of history.

3. When angels sing, may I heed their good news,
Listening instead of setting out my views;
Strengthen your Spirit dwelling within me:
Jesus, incarnate God of history.

4. When kings bow down, may I empty my store,
Give myself fully, now and evermore;
Knowing that all I have was given to me:
Jesus, incarnate God of history.

5. As the miraculous becomes a tale,
Sceptics are loud where all our words must fail;
You are my life who gave His life for me:
Jesus, incarnate God of history.

OH! BRING ME BLUE

Strand over strand
red/white the paper chain,
a dozen tree lights fail if one works loose,
an orange for a chocolate orange,
a chicken for a goose.

Brand over brand
red/white the paper flakes
an instant pleasure turned to months of pain,
like slush succeeding snow,
like wedding rain.

Hand over hand
red/white the Santa sleeve,
Oh! Bring me blue for her to purple red;
red for his blood,
white for his body, dead.

CUTE AS A CANDLE

Cute as a candle
A baby lies in straw,
A scene improbable
As any gone before.

See angels come
More outlandish than Mars,
A new star born
Stranger than dying stars.

Shepherds for us,
Wise men for the elite;
Then, for our own
Times, blood runs down the street.

So clever, yet
We radiate false charm,
Each year we need
The baby in our arms.

LOGOS

In winter's crystal light awakening
My soul, enkindled by the Spirit's fire,
Was blinded to the picturesque, desire
For even greater beauty quickening
In answer to the clarifying flame
Until it flared outside the human frame.

And yet it was a tiny human frame
Which had, until then, fed my hungry heart
With pictures fanciful, Renaissance art
Or Victoriana, it was all the same;
Then the flame leapt, unbounded and loose-limbed,
So that halos and angels were all dimmed.

By incarnational perception, Adam's flaw
Made good eternally through saving grace,
Yet in this child expressed in time and place,
A helpless creature lying in the straw:
Made flesh the Logos in a feeble cry
Which loneliness in death would amplify.

PARADOX

How shall the gold as bright as corn
Recall the night Our Lord was born?
And how shall silver, bright as day,
Remind us of the manger's hay?
For we have lost the stable's quiet
For decorative and festal riot.

How shall the purple for a king
Remind us of his suffering?
And how can red, symbol of blood,
Become the hue of Santa's hood?
For we have lost the oyster's grit
Replaced by factory surfeit.

Yet angels and the gifts of kings
Warn against undue sufferings,
That incarnation, in its place,
Is proof of universal grace:
Without the birth, no Calvary,
No cross, then no eternity.

WINTERS

i. STATES OF BEING

O for the cold, for the snow, for a moment
making all things clean, for a crunching
track in virgin white, for Christmas bells carried
by the East wind on a star-filled night, for
sledging down the rec on wooden crates, for civic
carol-playing silver bands, for scarves
unwrapping and for tingling hands, for coal fires with bursting
chestnuts in their
grates, for carol singers with full SATB, festive
cigar smoke as occasional
as sherry, and unexpected company at the gate come
to make merry.

But
now the warm, wet, West wind dragging
cloud, hustles out contemplation, urging haste between
the car park and the church as long redundant chimneys
seem to lurch and totter, as redundant
as the Christmas present sweater; then home
to an organised retreat, to central
heating, on-line shopping and a diary meticulously
planned, paradoxical in the age of the viewing
time-shift, oblivious of the corollary between the private and the
lonely; with Advent full of Christmas, Christmas makes us
weary.

> "Just about now, I think, if I am right,
> we will soon reach the border checkpoint where
> we will be classified as foreigners
> and thrown into prison for the night."

O for the time when you knew
where you were before our cosy world turned
upside-down, when you could recognise
almost everyone in town, when the few black
lads who came across to drive
the buses bolstered the fast
bowling on the cricket team, when the curry
shops, well, one or two, were
fine, and the odd sari
shop, but now some districts look more like
Karachi but that's the sort of thing you can't
say ...

The cards say
"Season's Greetings" instead of "Merry
Christmas", the Council has more than once tried to
ban Nativity Plays, the chapel where I went, well, until
my teens that is, is now a carpet
shop, the pantomime has been replaced by something from outer
space and there's football every day of the bloody
week: too
many choices; too many channels; too many
people; and, although I don't like to say it, too much
what they call
diversity.

But for the child, no sleeping in the cell,
relief at being left transfixed with fear;
what led to this she can no longer tell,
Yes, she believes the astrologers were sincere.

Blinded by daylight! Dark against the sky
the soldier says, "You are one of the few.
The regulations say that you should die
but they say nothing of a lucky Jew.

"I would not go so far as to express
less than contempt for your unstated state ..."

O for a quiet life
when I could say just what I like without
do-gooders sticking their oar in, forgetting who
made England what it was and would silence
anyone who dares to speak directly, without subordinate
clauses. I think ...

"... Better to curse the stranger than to bless
but in your case that would be recklessness.
"As soon as I turn round, just slip away ..."

... I say! I think it was much better when we had our own
town corporation and a mayor in his own town
hall, not faceless wonders too far over yonder. You knew
where you were then but nowadays everything is
somewhere else.

"... I want no trace; there is nothing to pay.
I can't withstand that something in your eyes,
which tells me there will be no compromise."

Not many
shepherds now abiding
in the fields up on the moors nor at
the Crib Service; nor many angels neither, now young girls
tart themselves up like women long before
their time ...

 Blinded by tears and sand she stumbles on
 until the fear of changing minds has gone;
 compared with this the stable was relief,
 a temporary home for joy and grief.

 "We have already suffered for this child
 born into poverty and now exiled ..."

... If
I was posh I would describe my sense of rage but people
left behind like me feel anger at the comfort they have
lost.

 "... In me the angel must be justified;
 The shepherds' tribute cannot be denied."

And then
my anger fizzles into shame, recognising that I have been a giant,
like Gulliver, tied down by countless chords of sentiment,
nostalgic ...

"Here are the pyramids our fathers built
whose shadows speak of freedom and of guilt ..."

... Nostalgic
for a time that never was, forgetting
in my cheap won comforts how
my parents and those who went before
struggled in a way to which I would be
unequal built
upon a solidarity—the hungry fed by the hungry—which I can
hardly
imagine ...

... more than another Moses at their foot ...

... I
am blind to oppression and my unthinking part in it.
I ...

... Where Israel's curse and promise both took root.

"Perhaps they will look kindly for his sake;
will it be my heart or their hearts that break?

"All we desire is shelter and rough food;
My quiet husband works with nails and wood."
"So are we all blessed with that kind of skill ..."

... I
am in more need now than I can say of Him
whom I abandoned carelessly ...

... "equipped to provide shelter, or to kill;
But work and food are scarce, what can we give
when we are pressed to find the means to live?"

... I
could and should have done more, now I find that selfishness and
pride have left me far behind ...

"I meant each word of my Magnificat
and should have cried more strongly, come to that;
Justice for all, whoever they might be,
As much for you as exiles such as me."

 Snow
 may be pretty but
 it is bitter cold
 for such a child; I feel it now as I grow
 old.

As they return across the desert sand
With Mary holding Jesus by the hand
Faith is restored:
His angel bids them to Genesareth's shore
Treading the path that Moses trod before,
Prophet and lord:
Pharaoh has died alone,
King Herod's plot undone
Christ will ascend his royal throne.

Will he return
for me who has travelled so far
from him?

All trace of scandal has been blown away,
As Mary marvels at her child at play
Hope is revived:
Exiles in Egypt, subjects now of Rome,
God's riches pour down on their humble home,
Life in him lived:
Unspoiled by earthly things
The infant king of kings
Promises more than our imaginings.

Will that promise of remembered
childhood be kept for those
who could not keep their promise?

His mother muses during tranquil days
On shepherd's pipes and thunderous angel praise,
Love will not fail:
Yet what was threatened might return tomorrow
She feels the point of Simeon's sword of sorrow
Christ will not fail:
The poor will be raised high,
The rich man sent away,
The price may be that he will have to die.

Must he die to save
me who would not save
him?

ii. THE EMPEROR'S WIFE

The Emperor's wife
wrote nine ranked haiku about
winter and the arts.

See the cosmic structured glow
snow on ice and ice on snow
light through crystal clear and bright
light refracted bluely white
light reflected whitely grey
packeted and on its way.

Light on snow and snow in light
blur the line of earth and sky
white conceals more than the night
beautiful obscurity
flakes of stone still and in flight
static and yet passing by.

Blind men insist that
light on their eyelids weighs more
heavily than snow.

Flakes of pure complexity
heaped in apparent formlessness
art or serendipity
with their own mysteriousness
even though the form is caught
computation falls well short.

Penguins deny that
meteorological
meringue lacks sweetness.

Ice from milk to water flows
then from water turns to stone
with the frost the flakefall slows
with the thaw flesh springs from bone
fronts of East and West caress
casting down their snowy dress.

Weather diviners
foretell variants within
A mobile constant.

Snow in light and light in snow
form and chaos interact
in a quasi quantum pact
change but still the status quo
beauty served by art and chance
in a mesmerising dance.

Engineers refine
infinitesimally
nested calculus.

Ice to snow and snow to ice
oscillating glove and vice
Field and stream in disarray
green and clear to white and grey
still as death then poised between
grey and white or clear and green.

 Philosophers state
 that beauty and virtue are
 incommensurable.

Beauty cruel and seductive
draws the eye and numbs compassion
the inductive and deductive
blanketed by fluffy fashion
landscapes of uncertain locus
rank impression over focus.

 Poets rhyme that form
 outlasts the immediate
 impact of colour.

Alien sun of rose and blood
harbinger of thaw and flood
sinks as the angle of its rays
coruscate with shattered glaze
leaving darkness to reclaim
freezing fields left just the same.

Composers hear sound
simultaneously whole
and deconstructed.

The wintry sun's brief enterprise
softly unearths a buried glow
Monet sparkles in our eyes
sun through crystal onto snow
every colour in the white
demarcated in the light.

Painters see colours
inside each other like white
then yolk inside shell.

Thus the dullness of the day
briefly rescued from the grey
shows how snow and light may be
shot through with intensity
promising that we will see
Monet's snow replaced by hay.

As the days stay light for longer
as the sun's weak rays grow stronger
snow breaks into dots and dashes
ice to slithers then to splashes
white and grey to blue and green
black and white to colour screen.

See the cosmic structure shift
death to birth and bound to free
flow from frozen pool from drift
stasis to fluidity
promise of fresh blossoming
winter softened into spring.

The Emperor's Wife
vastly prefers orderly
ranking to nature.

The Emperor's Wife
says beauty is hers alone
who graces the throne.

The Emperor thinks
that beauty has fled his wife
to live in winter.

iii. ON JESUS CHRIST THE APPLE TREE

When the first frost frays the final fruit
flaying its melody to wood and root
the tree of life is nothing but a cross
the cycle turned once more from gain to loss
bare branches stripped of gaiety and gloss.

I know my part in what came to pass
poised between a half-empty and a half-full glass
of crucifixion and redemption oscillating
this winter is a sorry thing
the bare trees sadly beckoning
To death before the birth of spring.

Scarcely the darkest bleakest day arrives
than my too feeble hope revives
from light's seed springs a riotous display
a spotless rose blooms on the shortest day
harbinger of hour-lived blossom blown away
laying new fruit in harvest hay.

How should such prodigality decay
 the new fruit nestled in the hay
 gnawed by the worm
 blown by the storm
 and in a strange way
 burned by frost
until all but the hardest seed is lost?

Yet no matter
 how expected or familiar
 after pain the cycle loses texture
 like a fading picture
 leaving its blackened architecture
 of a richness now unseen
 of a birth and a death and
not much in between.

His birth and his death and
 my birth and my death in history
 are almost equal as he meant them to be
 except for the cruelty
 he underwent for me or as I see
 it the cruelty
 I brought about
 not so much by what I sought as by
failing to stand out.

From where I stand in a society

 whose glass is at best half empty
 hope is more difficult than emptiness because we
 have lost the capacity
 to measure and compare accurately
in a landscape grown flat with the disappointment of hyperbole
 unhappiness often paradoxically
 being a form of self-indulgence as if perversely
 we allow our self-absorption to stratify
 the individual and the corporate identity
in unmysterious inarticulate reverie.

 Is not beauty
 without mystery
 not enough to satisfy

or

 should we say
 distance from reality
 leads to a sentimental
 rhetoric a suspicion of the equivocally
authentic?

There is nothing
more equivocal than the shadow
of a cross in the snow
of a tree gone back from blossom fruit
and leaf to skeleton and root
unless it may be
a nail in the manger and
thorns in
the hay.

Yet
are not the unequivocal reindeer
hoofs trampling the manger
incessant sleigh
bell tinkling the robin the snow
the 7/24 supermarket worshippers
in their different ways
escapes from shadow
a pretence that because the glass is full today
it will be full tomorrow
that there is light without
shadow?

Then
what are we to say
of this god who cries the bells with melancholy
in their Christmas pealing
the ambiguous tableau
of squalor in a halo
the warning of the apple and the apple tree
the weariness of failing
and the shadow of the cross never far away
the tears in the manger
and blood in the
hay?

If

 farewells were possible if

 they were not as outlandish as death

 we would bid farewell to the minor key

 to the art of plangency

 to the inflection to the subordinate clause to the way

the yolk and white are seen through

 shell to schadenfreude and

 the bitter/sweet the beauty

 in the sacrifice of pleasure for duty

 the construction and subversion of the sonnet and the

sonata.

Then
out of the wind and rain of modern winter
we carol sing for Jesus and for old time's sake
outside a pub and are welcomed in
with drink and well-remembered harmony
by people who occasionally
love Jesus perhaps sentimentally
although who are we to say
but love him nonetheless leaving us to take the more trying way
which is our pleasure our duty and our
privilege.

iv. CROSSING BORDERS

The cosmic meets the soft and slow
in the day's dying afterglow
as rose gives way to cloudy white
in silent prayer this Christmas night
nature recalls the time afar
of Jesus born beneath a star.

The steady hand of structured light
atoms in layers caught in flight
project the eye and mind away
from the mundane to eternity
giving us strength for the mundane
of boredom helplessness and pain.

On the border
between order and disorder
between fear of dying on the one side
of the divide
and of being sent back from the other
the exiles watch the trucks and cars piled with Christmas cheer
and remember
their time in Syria or Eritrea
when God was much more severe
and wonder
whether this God of softness whose adherents are given to
apparently
sanctioned bouts of self-indulgence will be
at least partly indulgent impartially.

John an exiled
Christian from Syria
rooting through the rubbish comes across
an English newspaper which says
they want to abolish the border
not to make it better
but to make it as bad for those who arrive as for those who never
make it and from now on there will be no rescue
from the sea and he wonders
whether crossing the sea now
is as murderous as crossing the desert used to be.

 The photographer
 in black and white says that colour
 draws the eye
 away from the complexity and subtlety
 of emotion to the brightly
 superficial.

 O wisdom coming
 forth from the most high teach us
 the way of your truth.

 The philosopher regrets to say
 that he must confine his speculations to the way
 propositions are consistent but will not assay
 the particularity of the ethical or the moral
 way.

Baptised in pasta steam in the refectory
standing beneath a shedding Christmas tree
against the rules of strict neutrality
John is given a Bible sent from his goal across the sea.

> O Lord of Lords come
> and with your Saviour's arms
> outstretched rescue us.

Turkey
deferring officials incongruously
crowned with festive paper hats mechanically
pick through a heap of anonymous heterogeneity
and extract an extra clutch of undocumented humanity
by way of celebration before closing early.

> O Root of Jesse
> come and deliver us and
> delay no longer.

The pundit opines
that the art of politics is delay
shelving a problem for a day
in the hope that it will go away.

In parallel with well-formed art
words draw the levels of the heart
the eye and mind more broad and deep
in stately progress seldom steep.

O key of David
come and free the slaves and break
down the walls of death.

Each generation has
its own way of not seeing
plantation slaves
infant factory hands
sweatshop fodder and
trafficked female sex workers
which through the ages have underlaid
the wealth not of nations but of the elite
in trade deliberately blind
to its sources resting on theories
of the uncontrollable global market
or the inevitability of the trickle
down of wealth to justify
its inactivity.

The work that merely pleases is not art
which must engage both mind and heart.

O Morning Star come
and bring light to those who fear
the shadow of death.

The distant wonder of the spheres
has come much closer through the years
now what we think of as a star
is hardly better than we are
just better paid and better glossed
with fame soon gained but sooner lost.

At last across
the border John
finds a Gideon in his cell
and studies the art
of living well not just
with reference to himself
but also to those who put his dossier on a shelf
and wonders if
they will go to hell.

O King of the Nations
Come and save the creatures you
fashioned from dust.

There seems to be no pattern
of concern
for which nations thrive or wither
the sanctity of a people or a border
or so it seems to John who watches
the United Nations goes back
to another resolution on Palestine while
refusing to say anything
about the Islamic State in Syria and Iraq.

We are defined by what we make
and not by what we give and take
whether the nations fall or thrive
the best creations will survive.

Perhaps in reaction to the Victorian
or to the pagan
the carols have turned melancholy
now mostly in a minor key
relating in words and harmony
to the Apple Tree.

> O Emmanuel
> king and law giver come
> and save us O Lord.

Ultimately
John thinks God's order is
incommensurable with feeble logic for
there might have been plutocrats in the stable and mendicant
fools without gifts now on their way and it would have made
no difference had there been
a crown in the manger
or nails in the hay.

confined in shape the unconfined
both law and wisdom undermined
God in man and man in God
blossoming of Jesse's rod
sand on stone and stone on sand
homeward through the barren land
loss in gain and gain in loss
from the manger to the Cross
fusing the human and divine
in his own self in bread and wine
Amen.

EPILOGUE

Less for my hope than to assuage my sadness
I help to set the crib and dress the tree;
The child I was in wonder now forgotten,
left with wisdom or is it misery?

Must everything we build disintegrate?
Lives struggling for sense and history,
Our plans gone ragged, friendships gone awry;
We shall leave nothing worthy of a memory,
Our only purpose is to try.

Without this child, life would make no sense,
For earthly love, no matter how intense,
Is vulnerable from outside and within
—for shorthand, let us call it sin—
For he is all we have of innocence.
But every time we place him in the crib,
I cannot help remembering
How we killed our Infant King.

Lightning Source UK Ltd.
Milton Keynes UK
UKHW011119160919
349871UK00001B/107/P